THE MANY LIVES OF ERIK KESSELS

aperture

PAUSING PHOTOGRAPHS
ERIK KESSELS

How does an art director in advertising end up exhibiting
in art galleries? It's a question I get asked a lot. It is
actually my work in the advertising industry that has
sparked my fascination for vernacular photography. As
an art director you often work with the images of others.
It's a part of the job I came to enjoy a lot, and in my
artist career outside of advertising I do the very same.

In design and advertising the perfect image is widely
perceived as the only acceptable image. This has always
bored me. I guess in a reaction to these beautiful but boring
images I went in search of real and imperfect photographs:
accidents, incongruity, frowns, wrinkles, fat rolls, blood,
bruises, overexposure, double exposure, awkward poses,
odd composition, bad lighting, and fingers in frame. It's the
faults, foibles, and mistakes that make the images I collect
feel authentic and human. I use this both in my advertising
work and in my work as an artist.

Essentially what I do is explore imperfection in a
"perfect" world and while doing so I'm on a mission to
make people look at images, and by that I mean really see
them. Often the photographs I find in flea markets or
online are full of imperfections, clichés, and patterns that
repeat themselves again and again in family albums the
world over. The amateur photographers before the digital
age weren't trying to take the perfect photo, they were
capturing memories and milestones and documenting life.

Today we shoot and shoot until we get it right. It seems
like we're living in the midst of a photographic renaissance.
We are making more images now than ever before. This
mass-produced image culture brings the value of an image
in contemporary society into question. Our current society
seems to be driven by consumption, or more specifically
overconsumption. We consume images like fast food: en
masse, shoveling them in with reckless abandon. The food

we consume is designed to look perfect but often devoid of any real substance. The same can be said for the deluge of images being pumped into our overfed and under-nourished retinas every day.

As a result we have become remarkable editors. We have developed the ability to filter images; to discern in a split second, a blink, or a click which are relevant or interesting to us and which ones to discard. Thanks to this remarkable skill, the bulk of these images wash over us like water off a duck's back; we barely register most of them. The downside is that this current image culture is potentially breeding a generation of visual illiterates, passive consumers who don't read, interpret, or process the bulk of the images they are force-fed on a daily basis. Quality is drowning in a sea of quantity.

The average life cycle of an image has become much shorter and the physical aspect of images has disappeared. There is actually an interesting upside to that because the abundance of images has sparked a new kind of photographic practice. It's no longer needed to take images of your own now that there are so many available online for the taking. The growing phenomenon of reappropriation is a result of this. I love to react to this and work with it.

In my work I try to make the viewers take a closer look so that they are forced to fill in the blanks by focusing on details. I want them to stop being passive and to actively search for answers like how, when, where, and why. For example, if the images are old I want them to notice the state that they are in, or I want them to notice the things that are absent in the photographs. By detaching images from their original context you change the way in which they are viewed. And with selection and curation you can enhance an existing story. You never alter the images or create some-thing that wasn't there already but you can magnify it. You create an opportunity for people to pause and take a moment from their daily image consumption to discover something new.

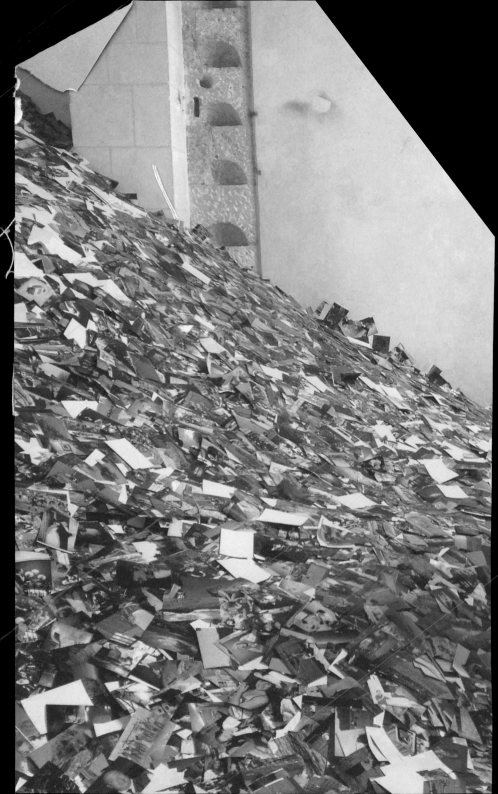

THE MANY LIVES OF ERIK KESSELS
FRANCESCO ZANOT

> *Some pictures are tentative forays without your even knowing it. They become methods. It's important to take bad pictures. It's the bad ones that have to do with what you've never done before. They can make you recognize something you hadn't seen in a way that will make you recognize it when you see it again.*
>
> —Diane Arbus[1]

Name: Frederik Johannes Peter. Surname: Kessels. Date of birth: 11 March 1966. Place of birth: Roermond, the Netherlands. Profession: designer, photographer, artist, curator, publisher, and creative director of the communications agency KesselsKramer. This publication investigates his work in the field of photography and art. This is a career which officially began in 1998 (the year his first photobook came out: *Missing Links*) and quickly evolved in the scene of a massive production, based on a principle of accumulation and multiplication which also involved the author-cum-actor himself. Kessels has donned countless masks, yet without ever abandoning his own identity: Frederik Johannes Peter Kessels always remains true to form. Perfectly recognizable. The roles that he plays, alternatively real (see above) or mimed (see below), constitute just as many other points of view on recurring subjects and themes. For this is his investigation strategy: his gaze is repeated and renewed. Even more than a Janus Bifrons, a Cerberus, or the Indian godheads Shiva and Ganesh, he is thirsty for perspectives. And he may come across in the widest possible range of guises, as if he had ten, a hundred, or even a thousand lives. Human, animal, and cyborg. Get ready for the invasion of ERIK KESSELS!

[1] Diane Arbus, *Diane Arbus: An Aperture Monograph* (Millerton, NY: Aperture, 1972).

Pages 7, 8: *24hrs of Photos*, Les Rencontres de la Photographie, Arles, France, 2013.

THE BOTTLE RACK

When Erik Kessels first approached the world of photography, he was already a successful creative. After studying as a window dresser (which seemed to him to be the most stimulating job on offer in his small hometown) and a designer, a stint as an illustrator in a major advertising agency, his move to London to work in another firm, and the founding of yet another agency in Amsterdam, at the age of thirty he knew just about all the mechanisms behind the world of communications like the back of his hand. Among those mechanisms that he took a dislike to there was one in particular: the immaculate beauty of its imagery. In advertising, everything has to look just perfect. Squeaky-clean. Flawless. With no blotches or smudges of any kind. This was what aroused his interest in photography, the arena of the mistake par excellence, when it's not all tarted up in a storm of technical wizardry as is so typical of professional practices. It's a matter of realism, in the sense that Gustave Courbet or Charles Dickens would have given to the term: heedless of any discipline or compositional rule, Kessels favored those imperfect images steeped in the mood of their creator.

Kessels is a bottle rack. His approach to photography is guided by a clear propensity toward overturning. First turnaround: in the split between photographers and non-photographers (a term covering any photo-fancier, from the talented amateur to someone wielding a selfie stick), Kessels fits in among the latter. Then there's his debut work: *Missing Links*. Published in 1998 and produced in collaboration with Julian Germain, it consists of a series of Polaroids of highly diverse subjects, the link between which is left open to the interpretation of the spectator. In practice, the responsibility (or pleasure) of the narration process is handed down to the onlooker. And this is the second turnaround. It takes place on the basis of the acknowledgment of a peculiar quality of photography: exuberance. Each frame normally contains a lot more

information than a single individual is generally able to decode, thus affording multiple interpretations. As Carmelo Bene once stated during a television broadcast, citing both Jacques Lacan and Ferdinand de Saussure in one fell swoop: "Meaning [signified] is a stone in the mouth of the signifier."[2] Likewise, Kessels does not entrap any image within a single possibility of interpretation, but rather he devises a mechanism which emphasizes its semantic depth and malleability. As such, the book is an ode to the free circulation of signs.

His following work, *The Instant Men* (1999), is a sequence of nineteen portraits depicting peddlers of roses and Polaroid snapshots. Turnaround No. 3: instead of striking a pose before "these forgotten photographers of the night,"[3] Kessels gets them to hand over the cameras and proceeds to photograph their surprised faces himself. The photographer is thus turned into the subject. He ceases to produce images and lets someone else do it, benefiting from Kessels's work (indeed, the "instant men" are paid to have their photograph taken). And so at the same time, Kessels turns the point of view around 180 degrees, inverting front and reverse shots, shedding light on what usually lingers in the shadows. This happens in one of the most famous photographs by Weegee (*Their First Murder*, 1941), who instead of photographing the corpse of a man lying on the ground, directs his lens toward the little crowd that has gathered to look at the deceased: expressing all the same dismay, but at the same time creating a monumental collective fresco of human pulsations. In Kessels's work, the inhabitants of Amsterdam are far removed from the usual stereotype. They do not have blue eyes and blond hair, but just bunches of colorful flowers which punctuate the passing of their working hours like great clocks. Resigned and dead tired.

[2] Carmelo Bene, in the *Maurizio Costanzo Show*, episode broadcast on June 27, 1994, Canale 5.

[3] Erik Kessels, *The Instant Men* (Amsterdam: Do Publishing, 1999).

STREET SWEEPER

Another small step needs to be taken in order to complete the revolution. Kessels is already ready. Basically, he deploys what he previously asked the protagonists of *The Instant Men* to do: to stop taking pictures. He jumps over to the other side of the barricade and bases his upcoming projects on the removal and recontextualization of preexisting images. Does that make him a collector? Not exactly, although this is the term which is most often adopted to describe those who exploit such an appropriational approach (besides the fact that, along the sidelines of his research, Kessels has put together an enormous collection of books and photographs over the years). His work resembles more that of the street sweeper. First of all, due to a simple matter of the "ecology of the image": Kessels acknowledges the boundless excess of imagery that surrounds us (later on he was to dedicate an entire work to this: *24hrs of Photos*, 2011, in which he piles together all the images uploaded to the Internet on one single day) and decides not to contribute to its further growth, in the certainty that everything he needs is already available without the need to produce anything new. Secondly, he does not accumulate precious objects, nor does he go hunting down works by famous photographers (like Sherrie Levine, Glenn Ligon . . .) or the symbols of a common imagery (Richard Prince, Barbara Kruger . . .), but rather he focuses on materials bereft of any intrinsic value: family snapshots, private albums, digital files downloaded from the Internet . . . This is the so-called "found photography," the direct descendent of the intuitions of Duchamp and Surrealism. Lastly, Kessels separates. He differentiates. Since he does not alter or manipulate the original photos in any way, his work consists in the pure act of selecting. This is a fundamental gesture: laden with civil and political meaning, Kessels makes a series of choices. Without the bane of composing frames or keeping overexuberant subjects in check, Kessels just chooses.

The year 2002 was a crucial one. Within a few months, Kessels issued his first two publications based on this process. *Useful Photography* brings together hundreds of photographs within a neutral container, all created for one specific purpose ("Photography from sales catalogues, instruction manuals, packaging, brochures and textbooks" states the only text in the entire book, tucked away on the back cover), which is then done away with entirely only to propose another reading, one free of all prejudice. This is the poetic, traditionally Dadaist mechanism of decontextualization, here giving rise to a new, antiauthoritarian archive, founded on criteria which are not the expression of an official power exerted from above with the aim of controlling and ordering, but entirely personal and at times wholly irrational ones. The model is that of the *Wunderkammer*, often cited among the ancestors of the museum, a triumph of blending elements, here mitigated by the explicit renouncement of exclusive possession.

In the second project, *in almost every picture*, the title just about says it all. Inside there are groups of images of a recurring subject. Like Vallier, the gardener in the paintings of Cézanne's later period, the same person appears repeatedly in a series of variants. Here, she's a woman with dark hair and a lower middle-class air to her, a great fan of full-length dresses and sunglasses. We are still very much within the dominion of the archive, enhanced through the narrative supplement triggered by the direct link between images. The scarcity of information available, inevitably typical of "found photography," dictates the rhythm and form of narrative progress, leading us on by deduction, following in the footsteps of the world of investigative sciences and Sherlock Holmes novels. Hence, every detail turns into a clue, and what before might have been distractedly overlooked now becomes the object of meticulous study.

SERIAL KILLER

Like a serial killer, Kessels acts following a characteristic modus operandi and proceeds by accumulation. His works consist mainly in the grouping together of images similar in terms of subject or type. Only once a given critical threshold has been reached, which may vary from a few dozen to thousands of exemplars, may Kessels declare himself satisfied and move on to the next target. However, this is never an exclusively quantitative issue but also a qualitative one. Unlike Allan Kaprow's tires (*Yard*, 1961) or Ai Weiwei's *Sunflower Seeds* (2010), for him no item is the same as another, but represents an entirely unique contribution. It's a matter of investigation. In Kessels's work, repetition has purpose quite unlike the accumulation of an indistinct mass of objects or similar figures. It is needed to account for the specialness of his subject: both to allow the onlooker to examine it in great detail, and also out of genuine voyeuristic pleasure, setting out to discover as much as possible. This twofold aim is met by projects like *Models* (2006), a complete guide to all the German police uniforms of the 1970s, and *My Feet* (2014), in which thousands of images of feet posted on social networks, photographed by their owners while treading on a wide range of different surfaces, are laid out side by side. They have the value both of social study and of political statement, dressed with a splash of fetishism.

On an even more macroscopic level, Kessels's entire creative palimpsest denotes a particular attention to seriality. Both works in which he addresses archives and popular photography, *Useful Photography* and *in almost every picture*, are in fact planned as all-out formats destined to be replicated over time. They function like magazines, television series, soap operas, or movie sagas. The same scheme is repeated issue after issue, episode after episode, albeit with new contents and fresh protagonists. They are thus positioned as indispensable points of reference, growing and broadening in line

with a scheme midway between the modularity of art and the obsessive reiteration of publicity and advertising. Like Giorgio Morandi and Matthew Barney, *Star Trek* and Instagram, they trigger a mechanism of expectation. And as the years go by, they establish a standard: it's also thanks to them that research into "found photography" over recent years has not only spread to every corner of the globe, but has achieved a very high level of average quality.

Useful Photography, which, just like any other mass production, is the upshot of a collective effort (the initial group, which along with Kessels consisted of Hans Aarsman, Claudie de Cleen, Julian Germain, and Hans van der Meer, was later joined by Ad van Denderen, Adriaan van der Ploeg, and Frank Schallmaier), has now reached its thirteenth chapter. Single issues have been dedicated to the likes of photographs of objects for sale on the Internet, missing persons, Palestinian kamikazes, competition cows, "before and after," individuals awarded for any achievement, porn actors, photography manuals, weddings, American shooting ranges, puzzles, and large penises. All together, these subjects make up a sort of atlas of the contemporary world, in which the bizarre and the distorted serve as tools with which to dig over the hard (protected) ground of normality and open up the field to the exploration of all that which lies around us. It's the same logic that guides Diane Arbus's gaze: her subjects don't so much serve to provide the on-looker with a panorama on marginal or extreme situations, as to land a blow at the very heart of civil society.

in almost every picture has an equally encyclopedic quality. Over fourteen years, Kessels has published just as many episodes of this saga. The ninth (2010) is dedicated to an anonymous dog with such a dark coat as to appear as no more than a blob to the camera lens of his loving owners. Eyes, nose, and mouth are never recorded on film, which at every attempt inevitably renders nothing more than a black silhouette. It's the perfect symbol of the tension between emersion and disappearance that drives all of us.

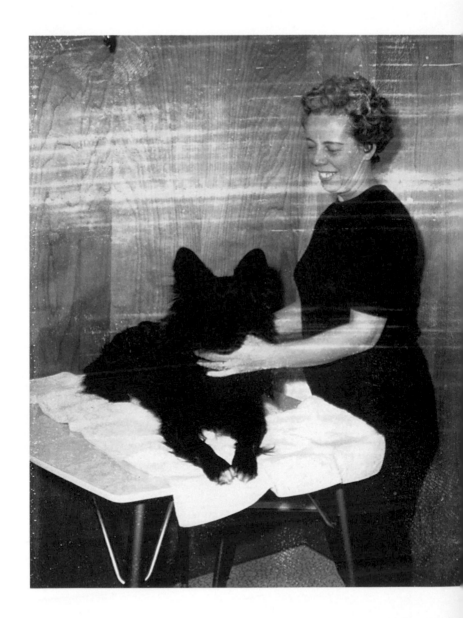

GUARD DOG

The best guard dogs continually patrol their habitat. Their aim is to defend their territory from external invasions; for this reason they never stop inspecting it carefully, ultimately getting to know it down to the very last detail. Kessels does the same thing. His interest is not focused exclusively on the subject of the images that he selects and gathers, but also on the entire operation which serves to produce them. In other words, each project of his investigates at the same time both *what* is represented and *how*. While keeping to a safe distance in time and space, he does not let himself be dazzled by appearances, rummaging around inside the very edifice of photography whenever he can, digging and scrutinizing and sniffing and unearthing and chewing and capturing. The very bones of photography itself emerge: its elementary framework, its ways of working, its dynamics and automatisms, often hidden beneath the sheen of habit, or so recent as to not yet have been put through the mill of theoretical analysis.

Let us take an example once more from the first publication of the series *in almost every picture*. Finding out a great deal about the life of Josephina Iglesias is not really enough to quench our curiosity. This group of images reveals something more about the entire typology to which it belongs. It works like a visual essay which seems to reflect the well-known observations of Pierre Bourdieu: "More than two-thirds of photographers are seasonal conformists who take photographs either at family festivals or social gatherings, or during the summer holidays."[4] Now we know that on these occasions, the photographer tends to place the subject at the center of the frame, to move further back as the subject grows older (perhaps because the sense of sexual desire lessens, or perhaps because it's the subject him/herself who

4 Pierre Bourdieu, *Un art moyen. Essai sur les usages sociaux de la photographie* (Paris: Les Éditions de Minuit, 1965).

feels ever less at ease in the close-up), to be generally un-interested in feet and the lower parts of the body, and to favor geometric backdrops and panoramic scenarios, possibly with the addition of the horizon. This is as regards the general approach. Instead, in specific terms, from *how much* and *how* he observes her, we can tell that the man behind the camera must have been deeply in love with Josephina.

FATHER

Family photography is one of the main sources of reference for Kessels's work. On various occasions he has drawn on family albums, exploiting their extraordinary visual and narrative potential. They represent his goldmine, an endless source of technical and formal inventions (the family photographer will stop at nothing to capture a souvenir of the most important moments), monuments, ceremonies, babies, animals, cars, tender humanity, and glaring errors. Over the course of the years, he has purchased hundreds of them, spanning different times and places. Hundreds of stories. And many thousands of individuals, of whom he thus becomes a sort of foster father. Furthermore, most of the images in these private anthologies are taken by the fathers of their respective families, perhaps due to the predatory instinct which has always brought photography close to men (enhanced by the priceless satisfaction of finding themselves endowed with a relatively simple technological invention), or perhaps by virtue of their lesser vanity. The fact is that they are the family members portrayed most rarely in this imagery. Kessels carries out their role once more. He divides that worthy of going down in history from all the rest, destined to oblivion. He chooses, yet he does so on the basis of very different criteria from theirs. While the original photographers selected all the images useful to perpetuate the memory of their own family in the best way possible and to establish a family line, as well as those most successful from the technical or compositional point of view, Kessels thinks of everything but this. He is primarily interested in

everything that defines the standard of this genre, as well as all that which constitutes a total deviation from it. There are obsessions that distinguish the gaze of the anonymous photographer from any other, and indeed Kessels is obsessed by the obsessions of others.

The second volume of *in almost every picture* (2003) is given over to the snapshots taken by a taxi driver of his own Mercedes during a series of trips undertaken with his passenger, who is always visible inside the vehicle. It's a sort of road movie stripped of all psychological, nervous, or sexual tension, and with the car always neatly parked on the edge of the road: anti–*Taxi Driver*, anti–*Gran Torino*, anti–*Crash*, anti–Robert Frank. In *ME TV* (2014), a Chinese lady repeatedly appears alongside her new television set, always in the same pose, the same framing. Despite her uneasiness, her presence appears to be a good excuse to celebrate her husband's much-longed-for cathodic dream coming true. *Mother Nature* (2014) and *Album Beauty* (2012) are two more collections. The former examines the practice of portraying women surrounded by nature. The context plays the same role as makeup, the only kind that men are capable of applying to their partners, at the same time constituting the substitution for handing over a little bunch of flowers. The latter is a farewell to the photo album affair, of which samples and examples are presented in the awareness that, right from their intimate and rather private tone, this is something that may never truly be repeated using new technologies.

Then there are the projects that Kessels produces using material of his own family. Here he taps into a theme recurrent in the history of photography. Indeed, there are many photographers who have placed their own relatives before the lens in a more or less continual fashion. A list as brief as it is incomplete of the most die-hard fans of this practice includes Nadar, Alfred Stieglitz, Edward Steichen, Harry Callahan, Emmet Gowin, Nobuyoshi Araki, Nicholas Nixon, Larry Sultan, Philip-Lorca diCorcia, Seiichi Furuya, Rinko Kawauchi, Marlene Dumas, Doug DuBois, and

Richard Billingham. Hans-Peter Feldmann and Leigh Ledare also drew on images from their own family archives, but Kessels approaches the matter from an extremely lateral stance. He exploits his own family to drive himself to the limit, or indeed right over to the B side of this genre: *Strangers in My Photoalbum* (2007) draws attention to the strangers who accidentally pop up in his old photographs. An entire population about whom we know nothing, and yet who are destined to be forever embedded in his family memories, like an army of ladies-in-waiting. Another reflection on photography emerges here: the abundance of information it provides is both a merit and a flaw. It provides us with a very in-depth knowledge of a subject or situation, but at the same time, it includes a great number of elements of disturbance. Photography is a distracted medium. While we ask it to look at something, it is actually looking at other things altogether. *My Family* (2000–ongoing) is something else entirely. It's a series of photographs that Kessels took of his own children every time they hurt themselves. Although over the last few years, images of children have become an arena of contention from the point of view of public opinion, these represent an all-out taboo. The children-violence combination is unbearable. Terrible. Unpresentable. And yet here, the bloodied faces, black eyes, and broken teeth have nothing to do with any form of abuse or aggressiveness, but are the upshot of chance (another key ingredient in the photographic language). And so these family portraits just need to be looked at from another angle, and they simply acknowledge that Kessels has actually found a way to make one of the soppiest and most banal subjects of photography interesting.

SON

The contrary of the father figure, here we also have the son. And Kessels, who proceeds by opposites, thus also takes on the viewpoint of the latter. He does so by introducing two specific elements to his work: nostalgia and play.

The nostalgia of childhood is the driving force behind *My Sister* (2003) and *One Image* (2016), both dedicated to Kessels's sister, who died in a road accident at just nine years a cut of original film footage of a table-tennis match in which she plays with Erik. The second is an enlargement of her last portrait. Another function of family photography is thus unveiled, consisting of bringing a memory back to life and offering consolation. Kessels experiments with all this on himself and goes on to stage it. This is a crucial gesture: on one hand he states his personal involvement in everything he does, sharing the same space as his subjects; on the other hand, he declares his own interest in photography as a way of recounting reality, making no bones about the authority of this medium. Like at the cinema, beneath each of all the images he gathers and re-proposes, the words "based on a true story" could be written. This is why they are so incredible. The protagonist of *Unfinished Father* (2015) is an old Fiat Topolino that Erik Kessels's father suddenly stopped restoring after suffering a stroke. It's a work made up of remains: automobile parts waiting to be assembled and photos documenting the various stages of the car's repair. The work is based on the principle of the *non finito*—think Donatello, Michelangelo, Giacometti, or Medardo Rosso—and thus unleashes the poetics of the interruption, so laden with intensity as it all takes places in the field of the possible. Everything that can be seen is "potential." What would this car have been like had Piet not fallen ill? And how would the complicated relationship between him and Erik have continued, had it not been broken off one day all of a sudden, just when it seemed they might finally be drawing closer once again?

Then there's play. The joke. It's one of the most typical recurring elements in Kessels's work. Not just subtle irony, but outright fun. You can laugh out loud before Kessels's work. And Kessels most likely laughs himself as he puts it all together. Just like Arcimboldo must have done every time he turned his subject into a fruit salad or a mixed

vegetable stew, making that infinitely small step from wacko to genius. Like Piero Manzoni and Maurizio Cattelan. And like Duchamp, of course, whose urinal (*Fountain*, 1917) firmly remains one of the most acclaimed divertissements in the whole of art history. For Kessels, play appears to be a necessary element to loosen the tension that restricts and contracts our body and mind. It's a matter of letting it all out. His works may be investigated after having passed through a liberating process. Let's look at a few examples. In *Strangers in My Photoalbum*, among those who turn up in his family photographs by accident, Kessels does not choose just those doing the most banal things, but there are also people playing the drums, wearing heavy medieval garments, or sticking their fingers up their noses. In order to examine and recount early photo blogs (*in almost every picture #8*, 2009), he chooses a Japanese one featuring the day-to-day life of Oolong, a rabbit capable of balancing anything on its head, from CDs to drink cans, from fruit to toilet paper. *Useful Photography #013* (2015) is dedicated to all those who post photographs of their own penis online, displayed alongside the most diverse range of objects (alarm clocks, computer keyboards, TV remote controls . . .) in order to highlight its size. "Laughter shakes the body, distorts the features of the face, makes man similar to the monkey,"[5] writes Umberto Eco in *The Name of the Rose*, thereby underlining the extraordinary potency of this act.

SHAMAN

Walter Benjamin removed the aura from the subjects of photographs. Kessels disintegrates it. His projects are first and foremost mechanisms of desecration. Everything featured within them is torn from the Hades of photographic immortality and violently trampled underfoot. Shamelessly. Poking fun at everything and everyone, thus in a perfectly democratic fashion. Tall and short, fat and thin, rich and

[5] Umberto Eco, *The Name of the Rose* (San Diego: Harcourt, 1983).

poor, the living and the dead. Then starts the path back up. In mathematics, it might be described with a catenary curve. In the field of religion, we might speak of conversion. What was photographed for one reason is appreciated here for quite another. The sarcasm that Kessels displays with regard to his subjects is countered by an equal dose of gutsy affection, to the point that, just like a kind of shaman, he turns some of them into absolute idols of the cult of "found photography." From riches to rags and back again—Josephina Iglesias, Oolong the balancing rabbit, Valerie (who would never miss a chance for her picture to be taken by her husband Fred while floating in water—*in almost every picture #11*, 2012), Ria van Dijk (who, from 1936 onward, took self-portraits looking down the barrel of her rifle at shooting ranges—*in almost every picture #7*, 2008), the Chinese lady in *ME TV*, the black dog, another dog (a Dalmatian, the protagonist of *in almost every picture #5*, 2006), all the "Instant Men" and many, many more besides: these are the heroes of Kessels's world. In some cases they even seem poised to surpass his own popularity, like Lassie with Eric Knight or Spider-Man with Stan Lee. Hence it is no wonder that Kessels's studio is to be found inside a deconsecrated church in the heart of Old Amsterdam, featuring a wooden pole-fence fort complete with watchtower in the place of the altar, and stained-glass windows telling the stories of saints and virgins.

TABLE OF
CONTENTS

PEOPLE CONSUME PHOTO- GRAPHS

...

...THEY DON'T LOOK AT THEM ANYMORE.

MISSING
LINKS

Missing Links (1997) is edited by Julian Germain from a collection of Kessels's personal Polaroids. It's the very first book Kessels published. The book is a foldout, which makes it possible to create your own sequence with the random and non-related pictures. Elements on their own often have no relevance unless they are put together or juxtaposed with something else. Then, a reference is created, a visual foil with which to feel context. *Missing Links* is the first attempt to initiate associations and encourage readers to make new links and interpretations. In his later books, Kessels has continued this fascination with creating stories, but with the images of others.

...ments on their ow...
...en have little or n...
...elevance until they are
...out together or juxtaposed
...with something els...
Then there is a refere...
a visual foil in which to
feel context. For how ca...
you tell what is beautiful
until you know what...
not beautiful is? Do...

Photographed by Erik Kessels **Edited by** Julian Germain

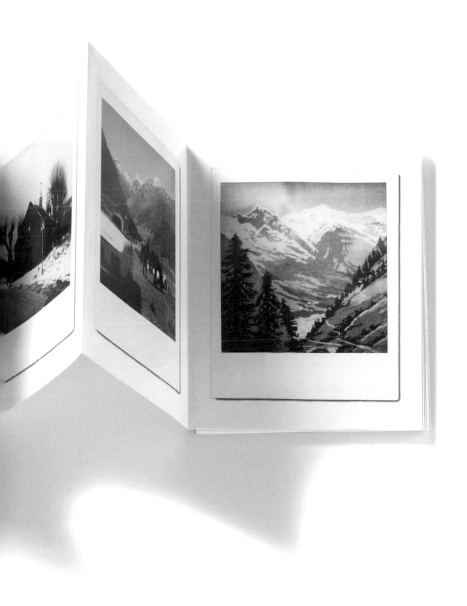

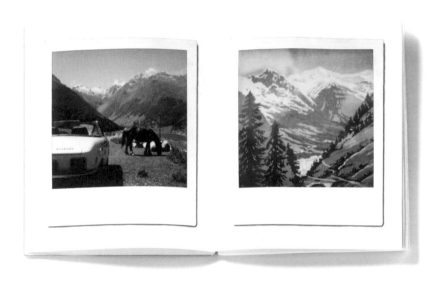

IN ALMOST EVERY PICTURE

1

in almost every picture #1 (2002) is a collection of hundreds of photos taken by a husband of his wife during the years 1956 to 1968. They are remarkable for their consistency. They are relaxed, but arranged. Amateur, and professional at the same time. Everyday, yet unique. The wife is the center of the pictures and gracefully poses in almost every image. Over twelve years we travel with her to different places. We see her age and her hairstyles change. So does her taste in fashion. The collection was found in a flea market in Barcelona. The photographer and his model were unidentified—until recently. Thanks to a campaign launched in collaboration with a Spanish newspaper, Josephina Iglesias was finally identified as the subject of the series.

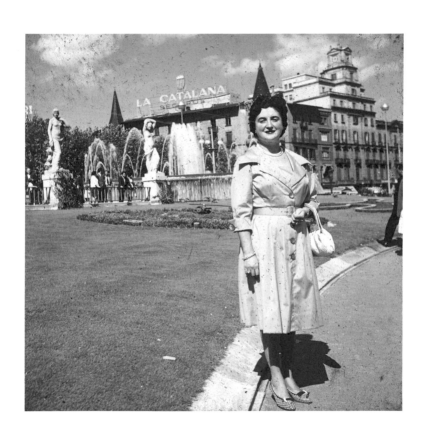

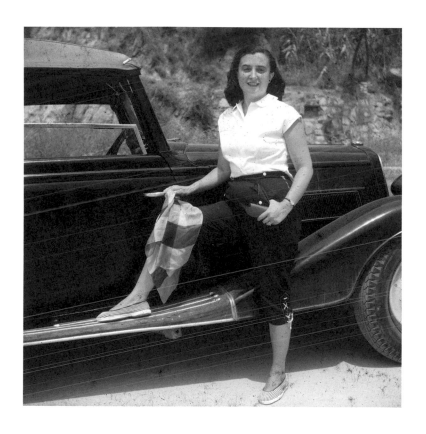

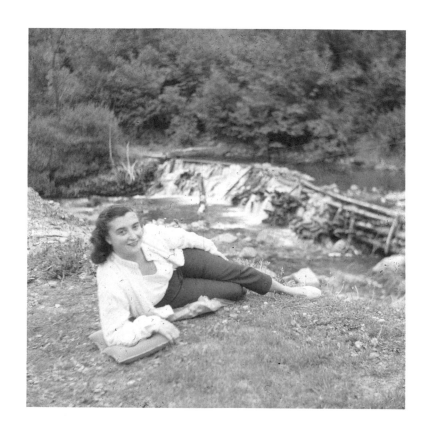

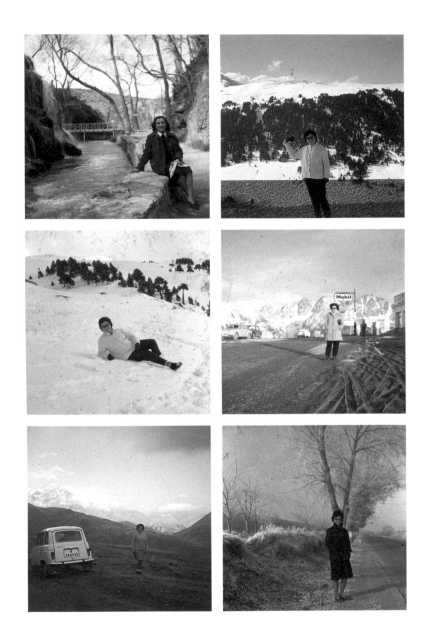

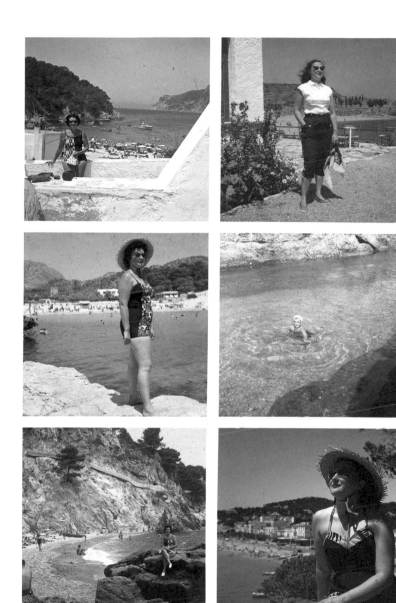

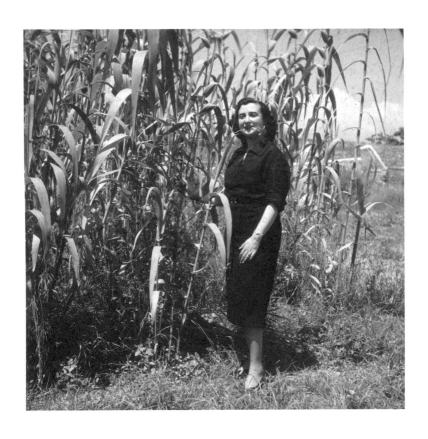

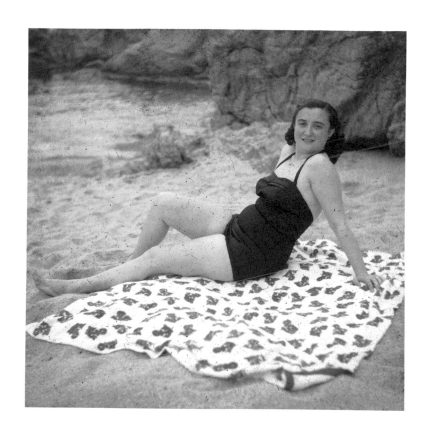

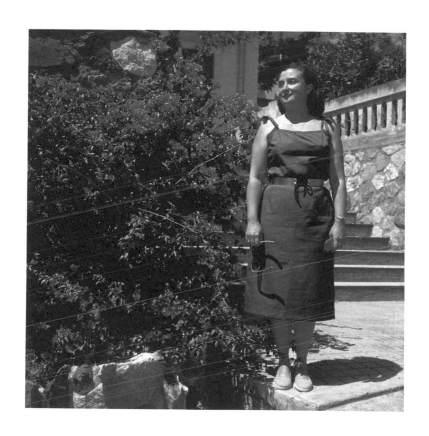

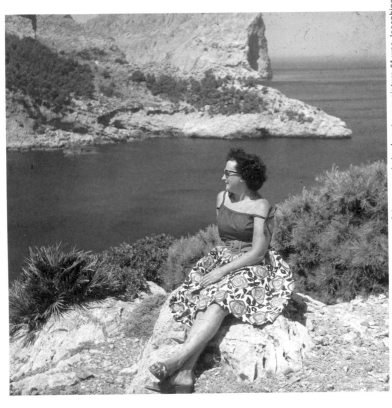

(After an extensive search, it turned out that the name of the woman in *in almost every picture #1* was Josephina Iglesias. A former colleague at a telephone company recognized her.)

IN ALMOST EVERY PICTURE

2

in almost every picture #2 (2003) presents a series of photographs taken and preserved by a Dutch taxi driver. Staring out from inside his Mercedes taxicab is the subject, an anonymous passenger, whom he came to know over a period of several years. The woman, who was physically disabled, was his companion on several long journeys across Europe, as he drove her on her holidays through Belgium, France, Switzerland, and beyond. Because of her disability, the passenger always chose this taxi as her mode of transportation. On their trips together, the driver made a careful record of the places they visited, making sure to keep his passenger always in shot, peering out from the inside of his cab. The images depict a curiously intimate relationship the pair developed while on the road.

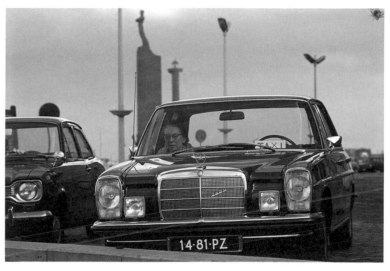

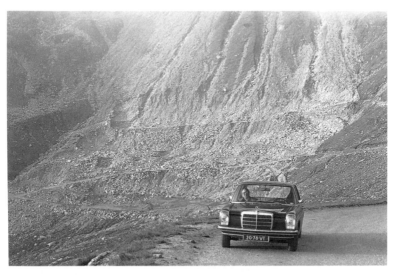

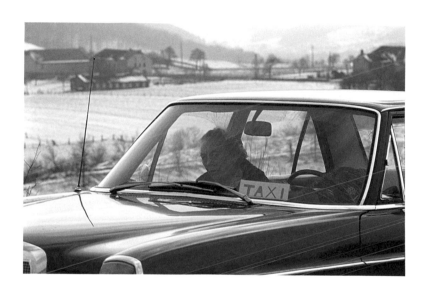

MOTHER
NATURE

Mother Nature (2014) is an ode to photographs that show females flourishing. It's curious that a man often takes photographs of his wife in front of beautiful flowers or in nature. As if a woman needs to stand there. Or maybe she deserves it. The photographs were collected from family albums. *Mother Nature* is a testament to the once-universal appeal to document and display the mundane. Often a repository for family history, the images usually represent a manufactured family as edited for display.

Pages 69, 72–73, 76–77: *Mother Nature*, in *(Mis)Understanding Photography*, Museum Folkwang, Essen, Germany, 2014.

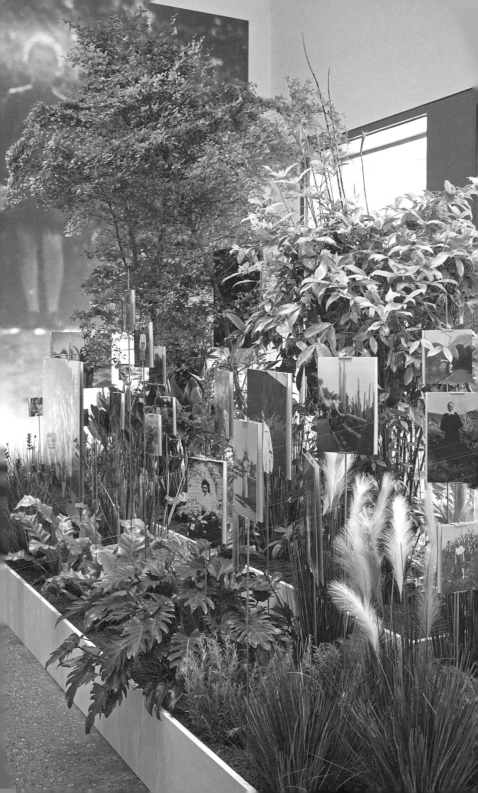

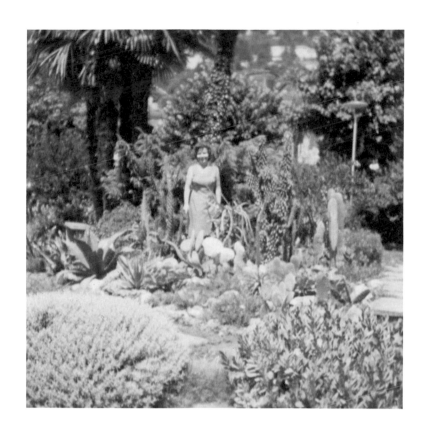

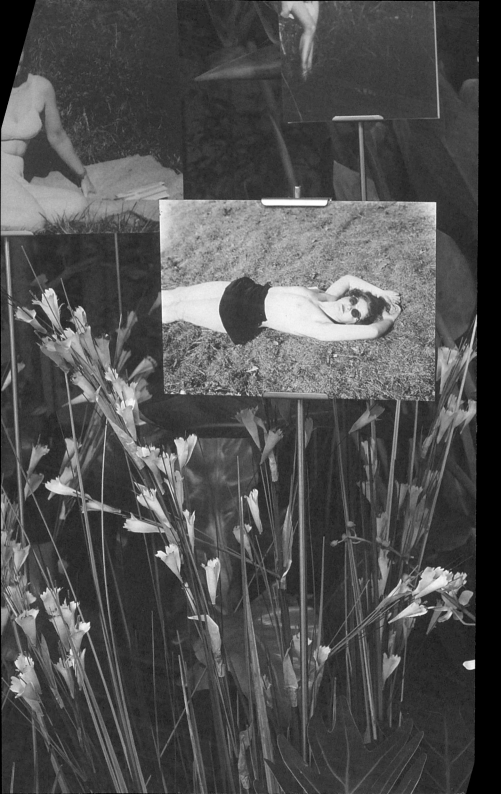

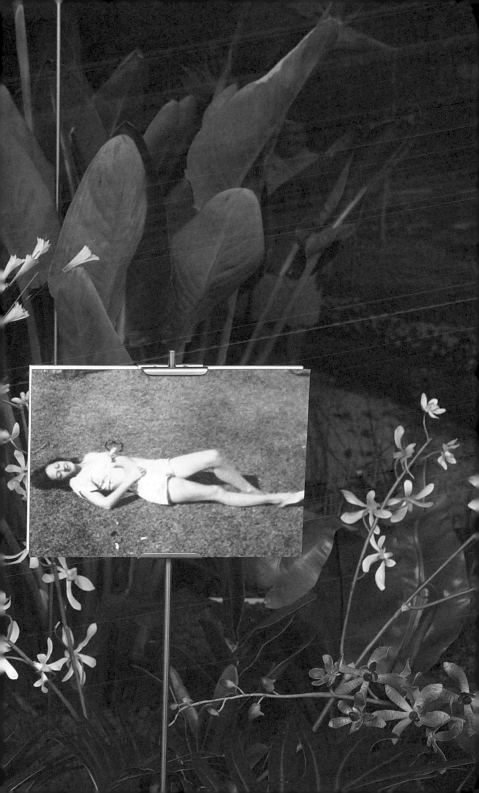

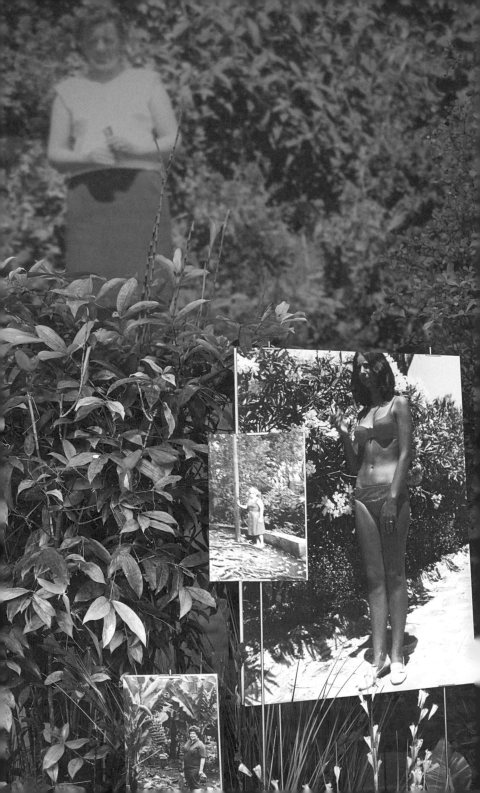

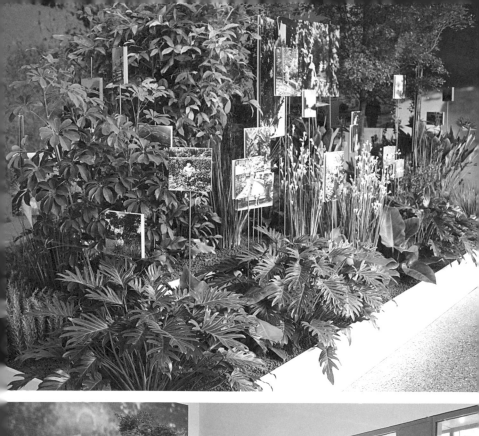

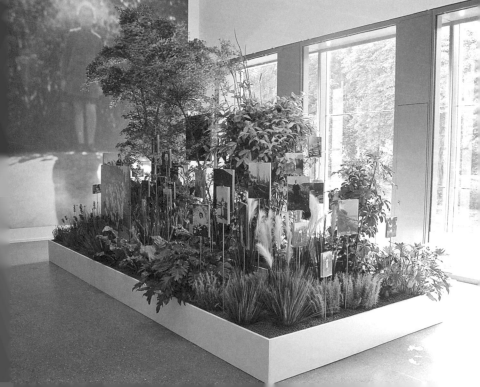

(Generally the older a woman is, the farther away she stands in the picture.
The husband makes the pictures and pushes his partner sometimes even to the edge of the frame.)

TREE PAINTINGS

Tree Paintings (2009) showcases some of Kessels's personal pictures, allowing readers to see the world through his eyes. Here, his images are of trees marked for destruction by loggers. Each close-up is of a trunk spray-painted with a letter, cross, or similar icon. What's striking is the amount of variation within these simple tags, how each "artist" stamps the tree with his own unique mark. The overall impression is eerie, as of a strange outdoor gallery lost in the wilderness.

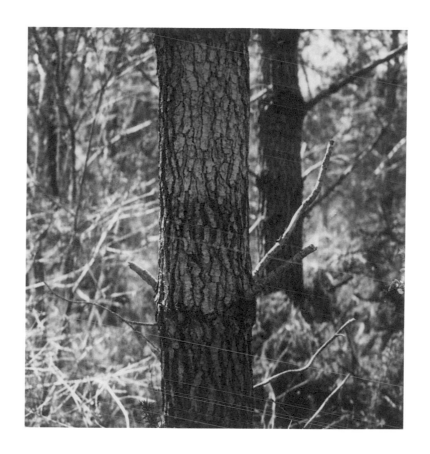

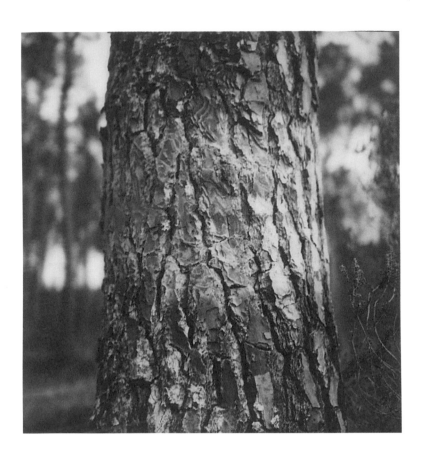

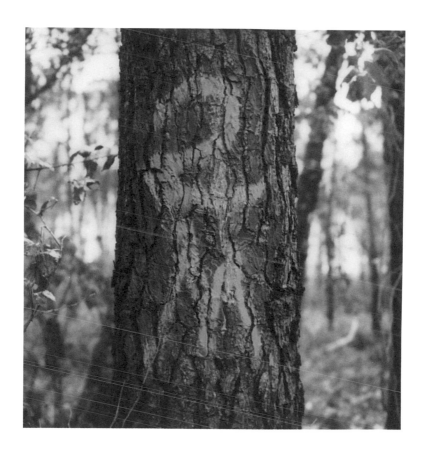

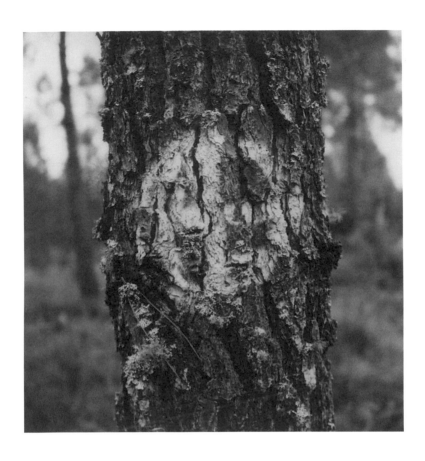

IN ALMOST EVERY PICTURE

3

in almost every picture #3 (2004) presents a series of photographs documenting what happens in nature. Without any of us knowing, animals of all kinds wander the forest every evening. They move invisibly and effortlessly in a natural ease with their surroundings that we as human animals have forgotten. Being curious and suspicious, we have invented a way of discovering their whereabouts with a camera that takes photographs by means of motion detection. We see animals in spontaneous poses and self-portraits sometimes with glowing, mesmerizing eyes that look like beacons. This camera technique allows hunters to track these animals during hunting season. And yet, the photographs produced are intimate encounters bridging the distance between us and what happens without us in nature.

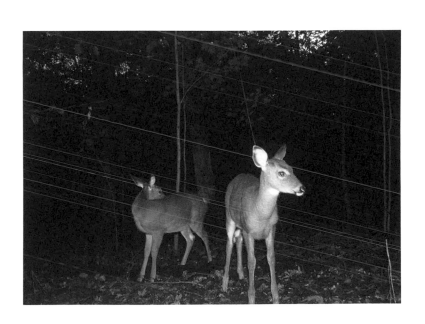

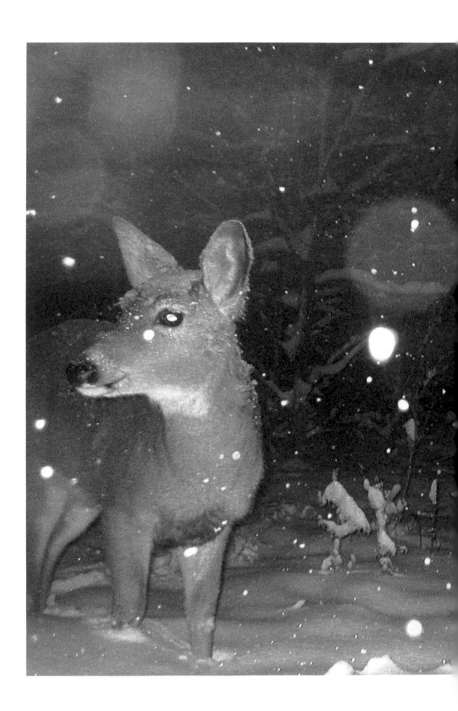

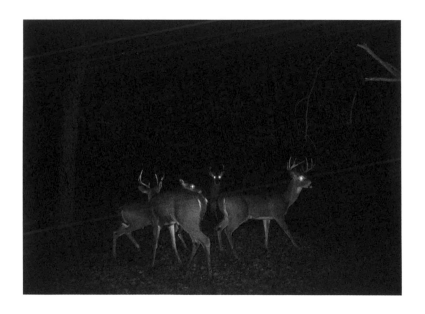

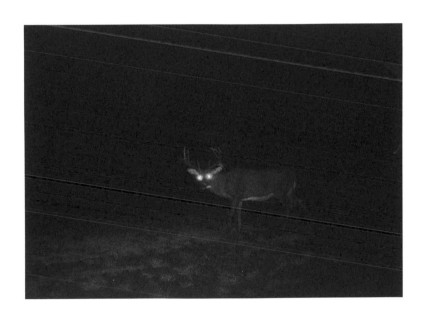

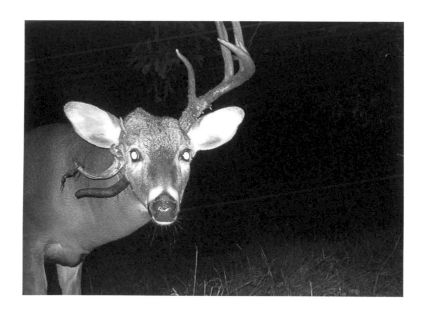

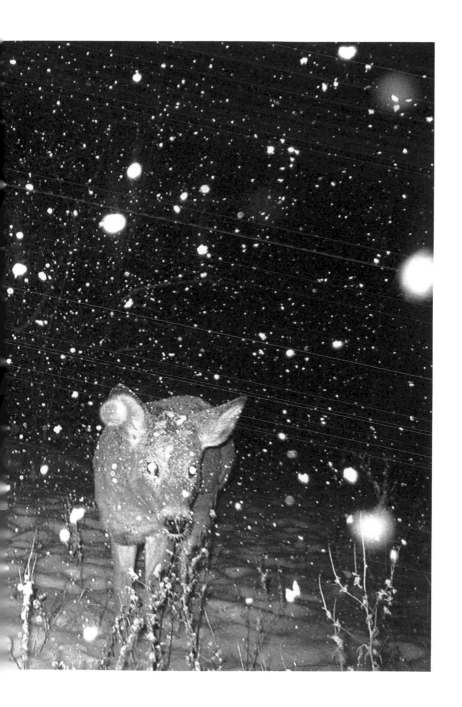

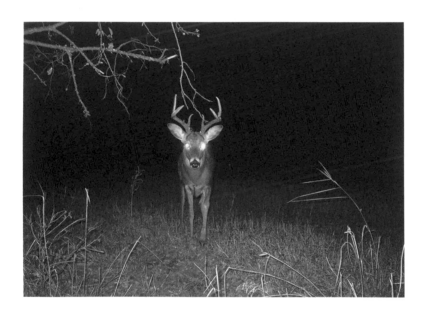

STRANGERS IN MY PHOTO-ALBUM

PEOPLE THAT APPEAR IN THE SAME PHOTOGRAPHS AS ME

People that accidentally join and participate in your photographs by appearing in the background or at its edges are only noticed when printing out your holiday snapshots. Specifically these people are the main subject in *Strangers in My Photoalbum* (2007). Found within Kessels's personal photo albums, these people are isolated, which gives them an importance they did not have before.

Anonymous and yet, because they are present in your photographs, they become part of your (photographed) life. A man changing a tire, a girl on ice skates. Who are they? What kind of life do they have? How do they feel? Their lives are presented to you without revealing them.

 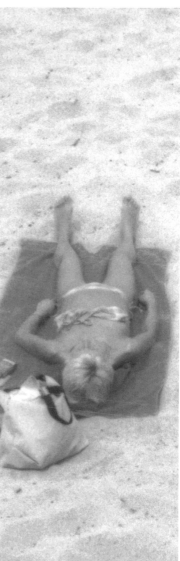

PHOTO
CUBES

Photo Cubes (2009) is an exploration of the photo cube—a strange novelty item now largely consigned to history. Each photo cube features advertisements or family snapshots strategically placed around five of its faces. The result is a weird (and sometimes wonderful) juxtaposition of images.

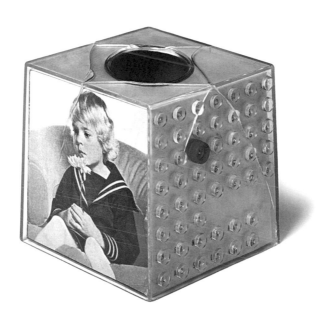

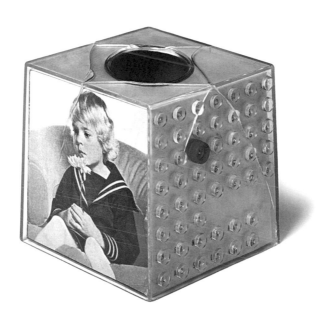

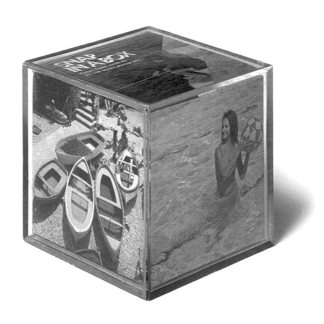

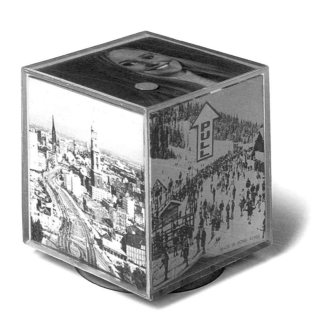

MADE IN HONG KONG

121

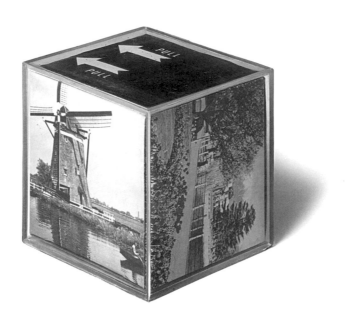

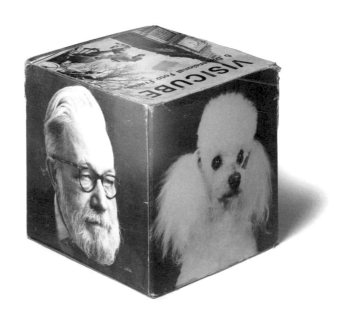

123

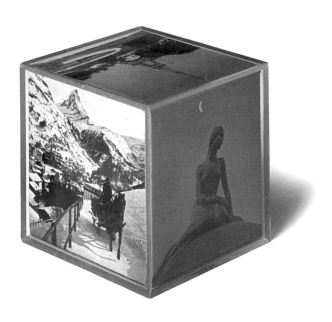

ERIK KESSELS, THE ARCHAEOLOGY OF A KIND OF PHOTOGRAPHY

SANDRA S. PHILLIPS

Almost single-handedly, Erik Kessels has made amateur
photography, or vernacular pictures, important again to
look at and think about. In the past few decades, most of
us who are interested in this medium have been accus-
tomed to seeing pictures we like, pictures we think are
worth looking at, in art galleries or in museums, even.
Those are the serious pictures. For many of us who peruse
social media, we have fun looking at pictures of our
friends' dogs or children or their new cars or refinished
kitchens or whatever else the Internet has to offer. There
are literally millions of those pictures, and they are
usually distinguished from the other pictures, the more
serious ones in galleries and museums, by a kind of
intimacy and uninspiring similarity.

Kessels has brought vernacular photography back to
center stage. He insists we look at these pictures in places
of aesthetic delectation. He makes us reconsider these
pictures, urges us to look at them again, persuades us--or
tries to—that they deserve attention of the kind we give to
pictures in reflective spaces like museums. The shows he
makes are in those spaces, and they are filled with these
found vernacular pictures.

He is not the first person to ask us to seriously regard
vernacular photography. In 1966 the Museum of Modern
Art in New York published a book written and conceived
by John Szarkowski called *The Photographer's Eye*. On
the cover was a photograph of an eye chart in a bedroom;
it looked very much like a picture by Walker Evans, but
it was, in fact, an anonymous photograph (it was later
discovered to be by a Wisconsin photographer whose work
Szarkowski found in the Wisconsin Historical Society).
This book, published two years after an exhibition of the

same name was held at the museum, contained other authorless pictures, or photographs made by amateurs, or tradesmen, or photographers who worked in small towns and recorded the memories of their communities. Vernacular pictures fill the pages of his catalogue, but they are seen alongside other photographers whose names we know and whose pictures we recognize: Edward Weston, Walker Evans, Ansel Adams, Henri Cartier-Bresson, and many others. The book, and the show that preceded it, were designed to present the particular formal characteristic of photography; the intent was to show how photographs were distinguished from other kinds of image-making, and how photographers used these formal tools to construct pictures. Szarkowski established these basic photographic parts in different sections: one was called "The Vantage Point," another called "Time." The opening section was called "The Thing Itself." He was trying to establish the medium as one that, though widely used and known, could also be a personal expression, even if that was not the intention.

Szarkowski's predecessor was Edward Steichen, and Steichen's most important and most famous exhibition (with an accompanying book) was *The Family of Man* (1955). Where Steichen was interested in the accessibility of photographs, and molded his most popular show to underscore the similarities we all share as human beings, Szarkowski was interested in defining what makes photography particular, and how engaging in its particularity could show us a vigorous, personal, various medium, and pictures we might want to pore over with delight and refreshment, pictures that made us enjoy looking at them, or made us surprised by them, or even horrified, or pictures that made what they depicted so interesting that we couldn't take our eyes off them.

Erik Kessels is an archaeologist whose medium is contemporary photographic images. I believe it is important to note here that though he works with photographs,

his concerns are with images. The distinction is small
but important. A photograph has usually been considered
something concrete, something you can hold in your
hand and look at, something you find in a book when
you go to the section called "Illustrations." An image is
a more generous concept, and also more imprecise—you
can have an image in your mind's eye; it doesn't have to
be printed on a piece of paper. You can say you have an
"image" of something and not know how it is delineated
clearly. In contemporary society, the word is commonly
used to describe pictures we find on the computer—in
other words, "image" carries with it something more ideal
and less attached to actual fact. When Kessels talks of
"images," this is what he means. He is concerned with
the huge tsunami of images our cell phones have made,
or the earlier pictures that came out of the drugstore's
automatic color processing machine. Yes, some of these
are photographs as we remember them from our youth,
but many are not—they are part of the ether of "images."
This is why his collections are so satisfactory: he works
like an archaeologist to discover the strangeness, even the
hilariousness of our current culture. He finds humaneness
in these reams of images, and also pathos. He works not
like a documentarian, but like a conceptual artist. Like
other conceptual artists, he courts the boring. Many of
these pictures are made in series, giving them a built-in
narrative structure. But he finds the strange, the odd-
ball, the hidden, the hilarious, and in these selections of
pictures, which we all recognize for their commonplace-
ness, he questions who we are and what we have done with
what we have been given. And I, for one, am grateful.

MODELS

Models (2006) features 132 German uniforms and how they should be worn. During the course of one year in the 1970s, the German government undertook a comprehensive photography project. In order to instruct police officers in every district and region of Germany how to wear their specific police uniforms, proper reference was needed. Models were photographed to show exactly when and how to wear uniforms for different ranks, seasons, and occasions. The project entails a book as well as an installation and gives a close-up look at, for example, how a female police officer should wear her Summer Service Uniform as well as how to wear her raincoat in the case of inclement weather. No matter if you're a standby traffic officer, part of the helicopter squadron, or a medium-level horseman, *Models* provides the reference for the correct style of outfit.

Pages 136–37: *Models*, in *Loving Your Pictures*, Les Rencontres de la Photographie, Arles, France, 2007. / Pages 138–39: *Models*, in *Loving Your Pictures*, Centraal Museum, Utrecht, the Netherlands, 2006. / Pages 140–41: *Models*, in *Loving Your Pictures*, Les Rencontres de la Photographie, Arles, France, 2007.

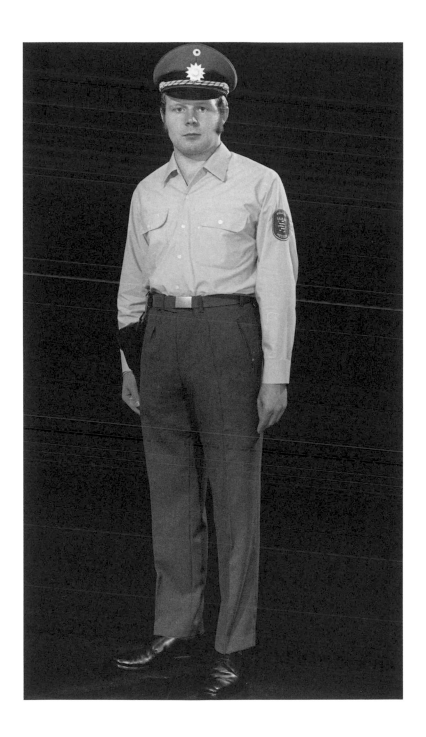

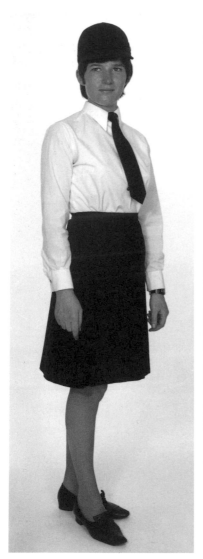
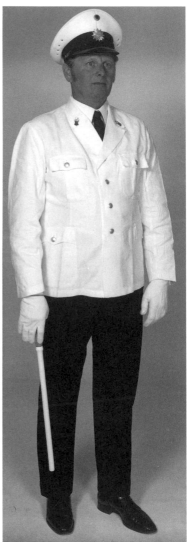

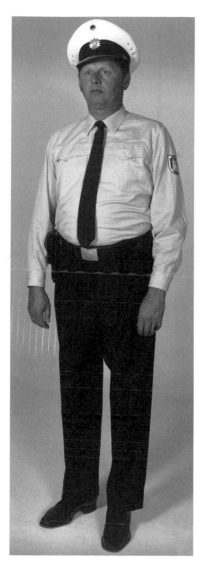
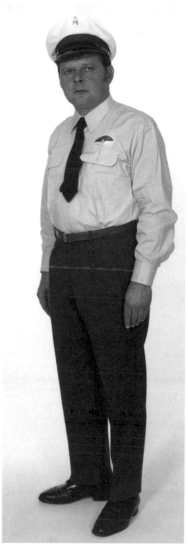

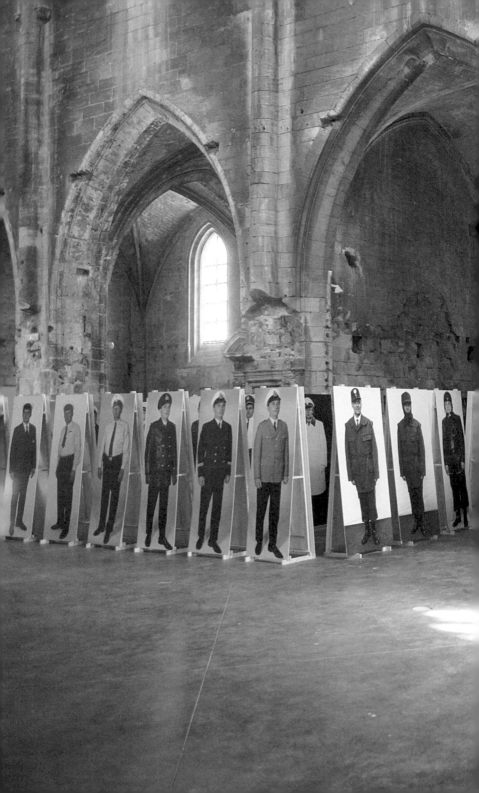

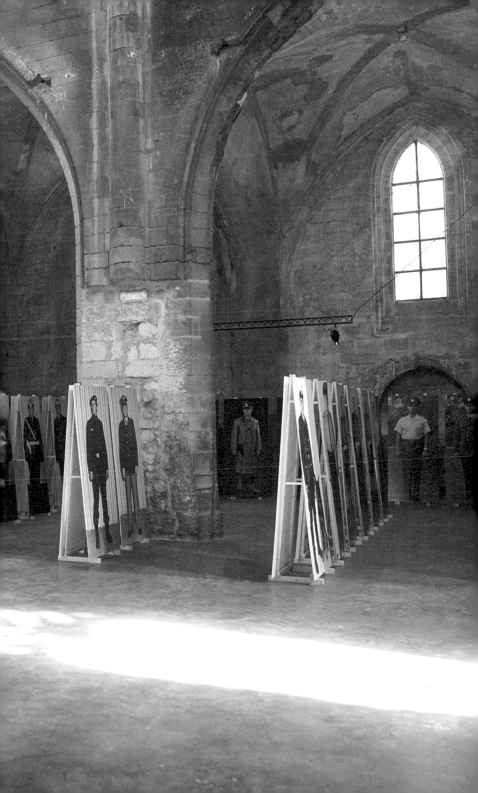

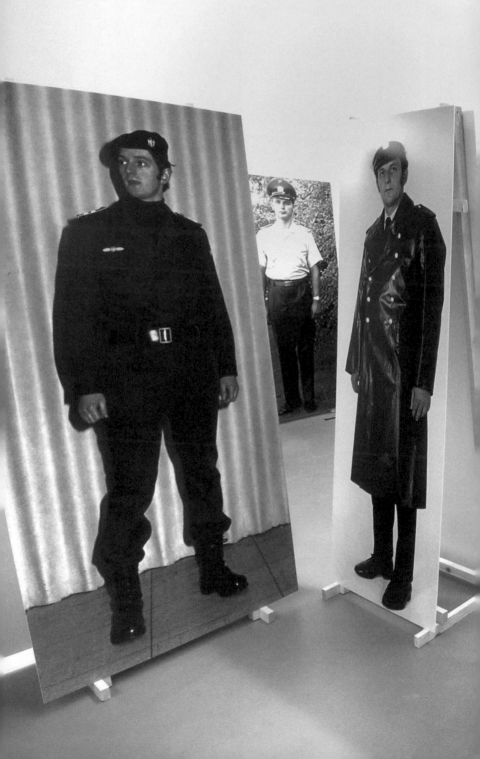

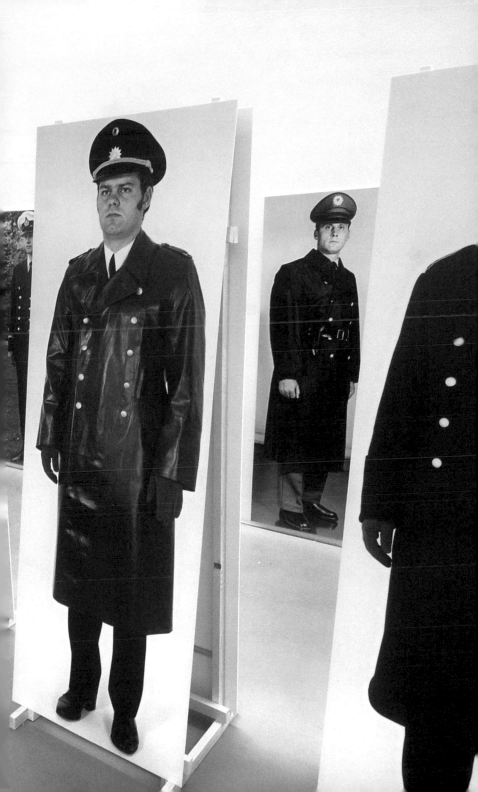

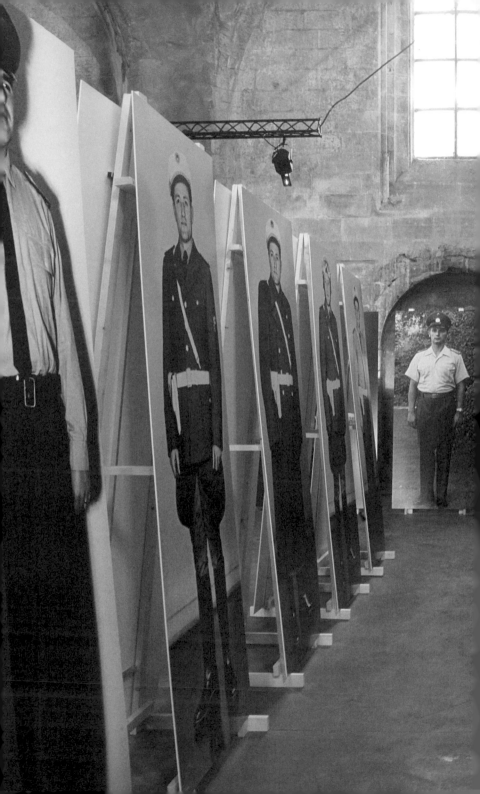

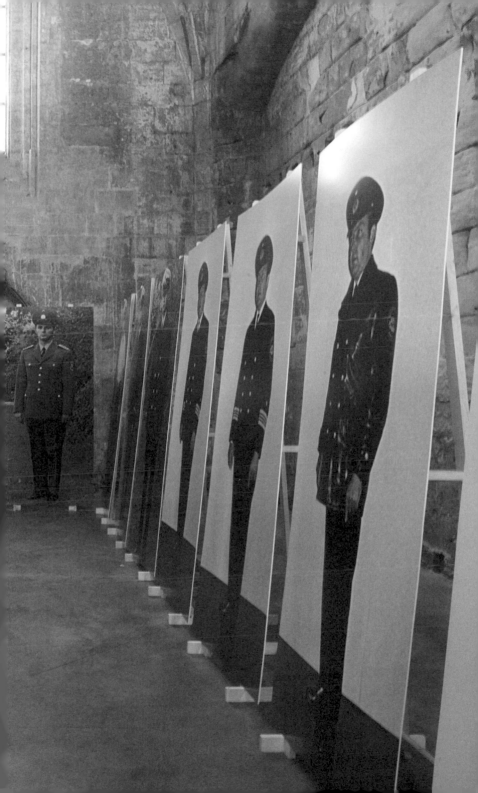

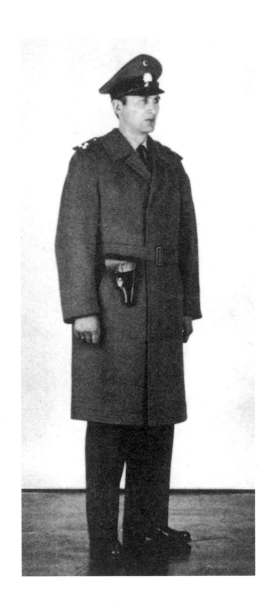

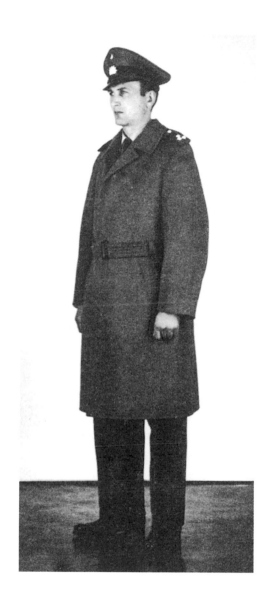

LOVING
YOUR
PICTURES

Loving Your Pictures (2006) brings together different manifestations of "vernacular photography" or "amateur photography." The exhibition of this material offered another look at various photographic series outside their original and intended purpose, and most especially, to experience them physically and viscerally in an exhibition space. Often installed larger than life, these experiments with scale and physicality, in tandem with their recontextualization, allow for viewers to add new meanings to the images with different considerations and perspectives. *Loving Your Pictures* finds delight in the work of these fellow citizens and their cameras and asks us to consider the countless photographic wonders that go on around us each day.

Pages 150–51: *Loving Your Pictures*, Centraal Museum, Utrecht, the Netherlands, 2006. / Page 153 top: *Loving Your Pictures*, Les Rencontres de la Photographie, Arles, France, 2007. / Page 153 bottom: *Loving Your Pictures*, Centraal Museum, Utrecht, the Netherlands, 2006. / Pages 154–55: *Wonder*, in *Loving Your Pictures*, Centraal Museum, Utrecht, the Netherlands, 2006. / Page 157 top: *Strangers in My Photoalbum*, in *Loving Your Pictures*, Centraal Museum, Utrecht, 2006. / Page 157 bottom: *in almost every picture #1*, in *Loving Your Pictures*, Centraal Museum, Utrecht, the Netherlands, 2006. / Pages 158–59: *Loving Your Pictures*, Les Rencontres de la Photographie, Arles, France, 2007. / Page 160 top: *in almost every picture #1*, in *Loving Your Pictures*, Centraal Museum, Utrecht, the Netherlands, 2006. / Page 160 bottom: *in almost every picture #3*, in *Loving Your Pictures*, Les Rencontres de la Photographie, Arles, France, 2007.

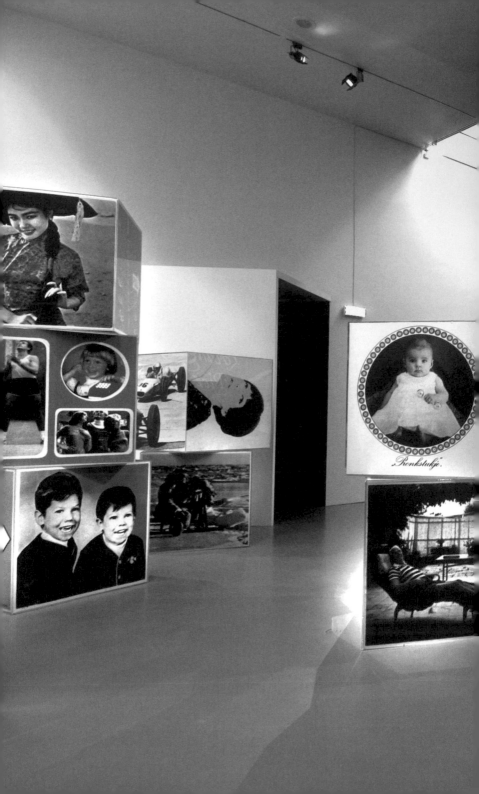

Pronkstukje.

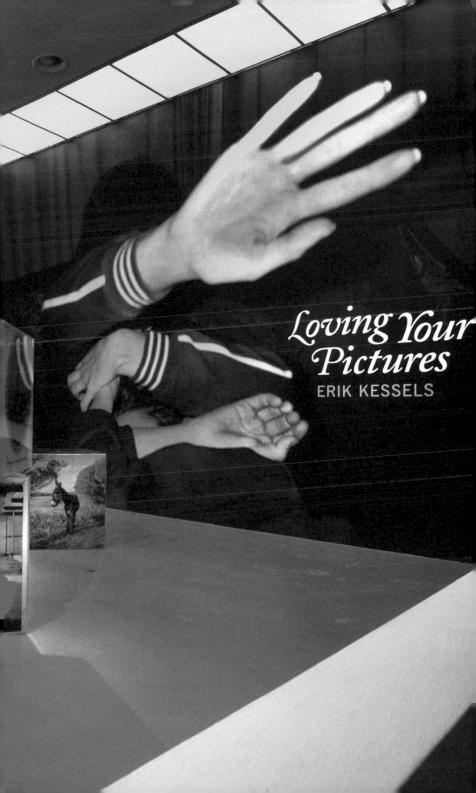

Loving Your
Pictures

ERIK KESSELS

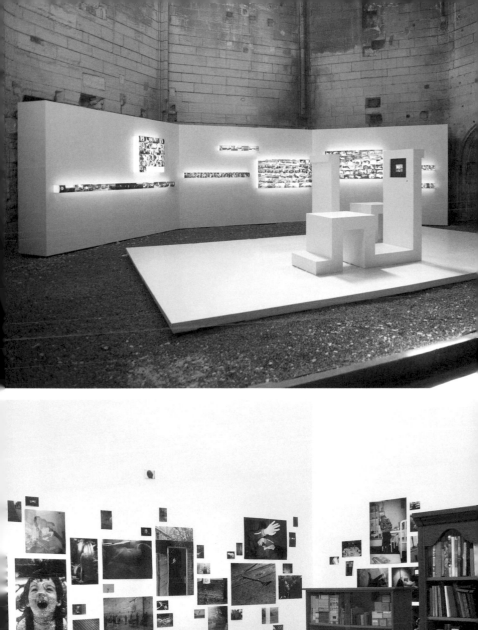
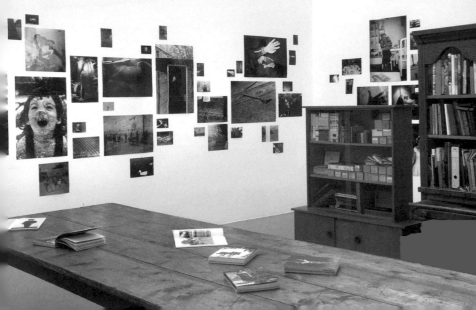

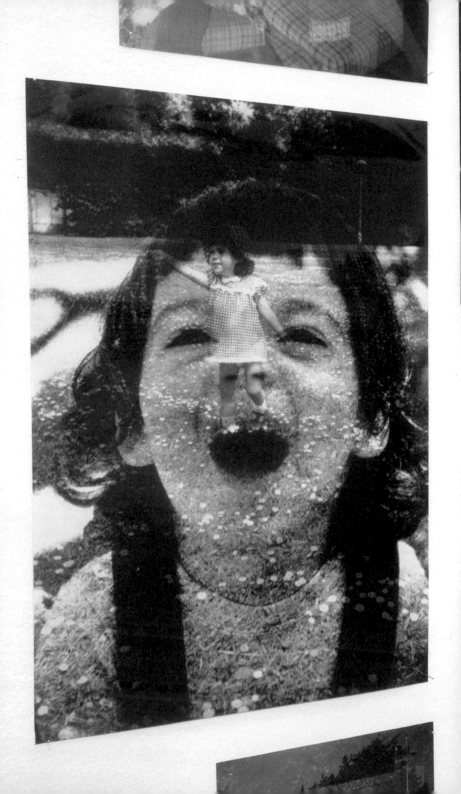

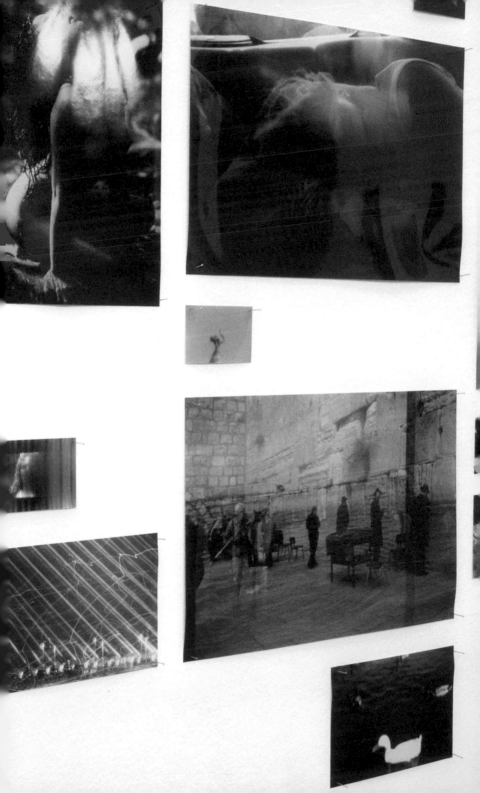

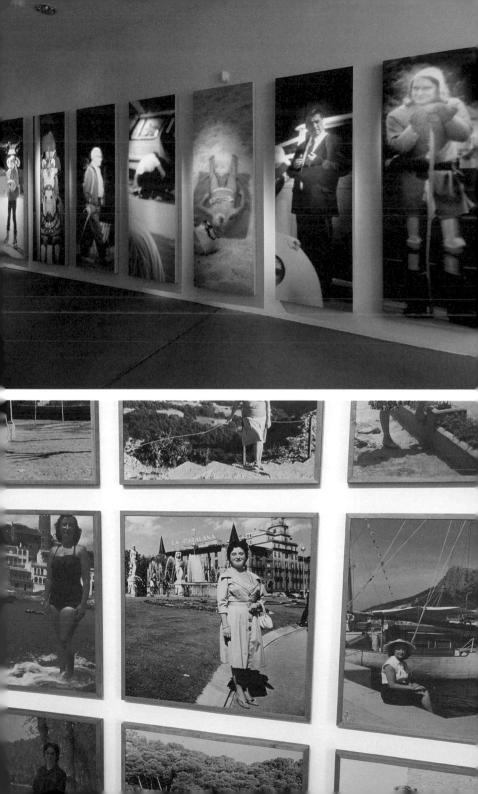

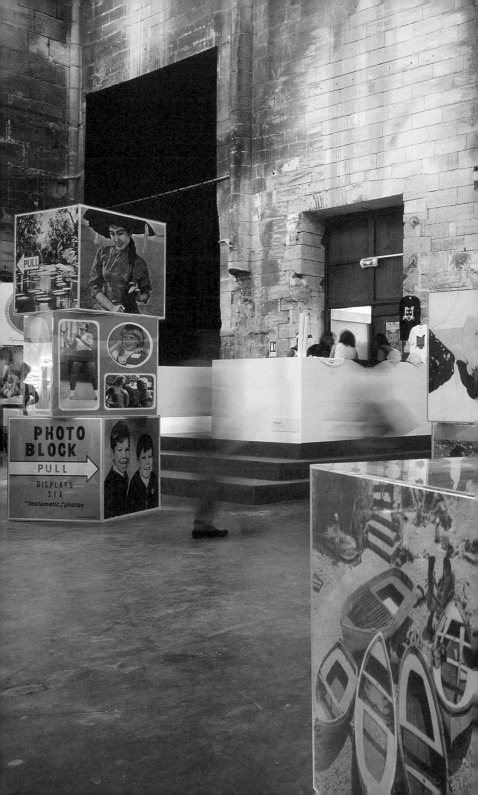

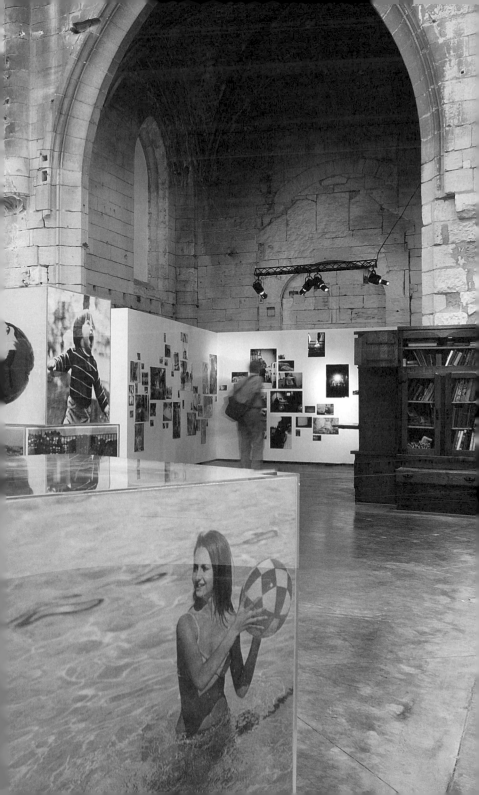

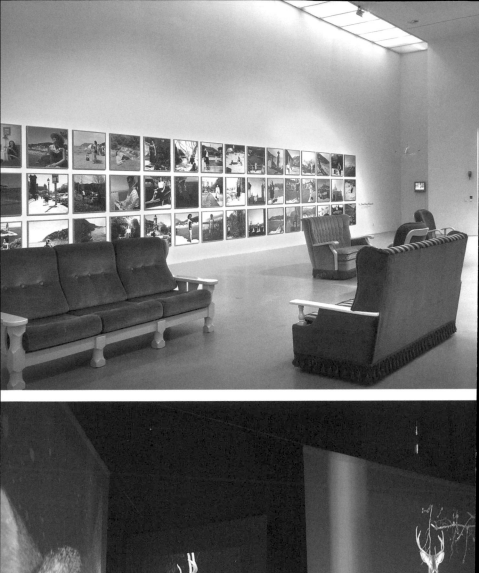

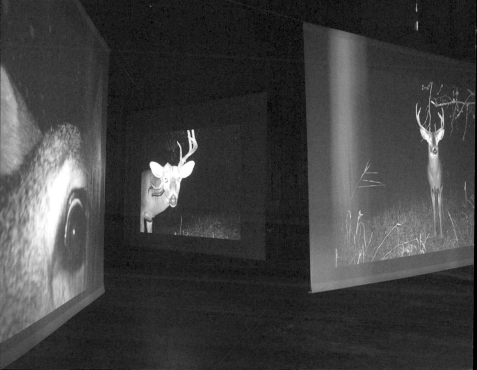

IN ALMOST EVERY PICTURE

EVERY

PICTURE

4

This edition of *in almost every picture* (2005) contains the story of sisters. They are sororal, or non-identical, twins who take extra care in their styling and wardrobe to make themselves appear more identical than they are. On the promenade, photographers discover their little ceremony. In between the times of the photos, the twins make an effort to arrange clothing, bags, shoes, and hairstyles that are exactly the same. The time is World War II and despite our best efforts to keep the horrors of war from invading this delicate and wonderful situation, in the final images we see that one of the twins is missing. The remaining twin, as if by instinct, leaves room for her sister in the ensuing photographs.

Pages 174–75: *in almost every picture #4*, in *Secondhand*, Pier 24, San Francisco, 2014–15.

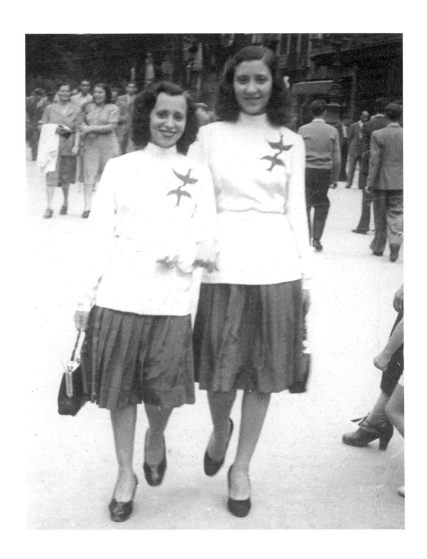

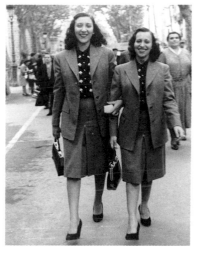
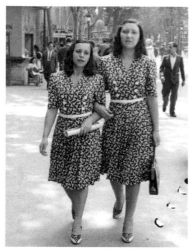
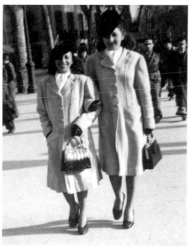
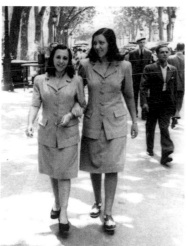

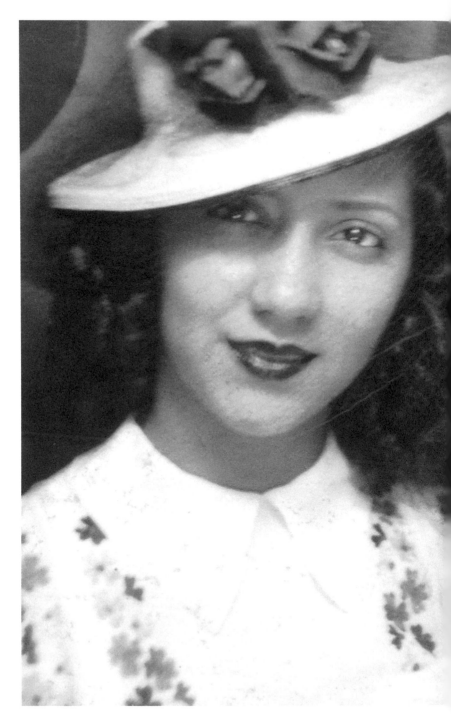

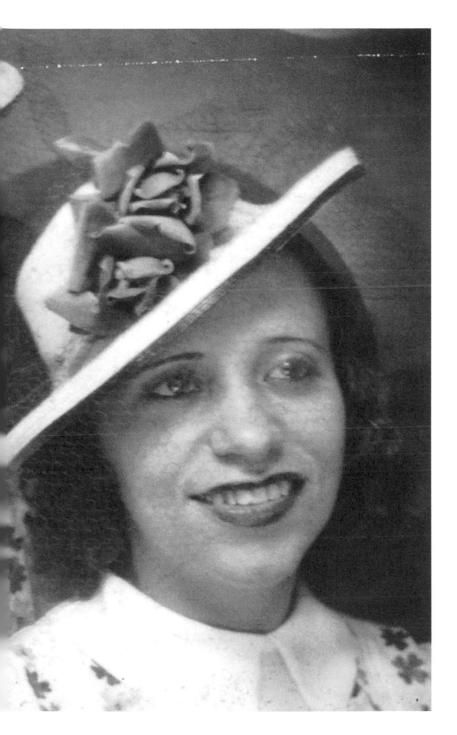

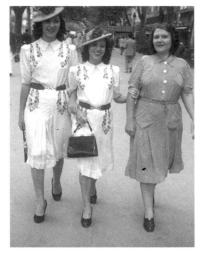

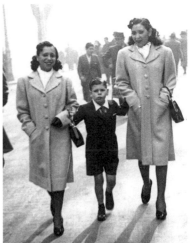

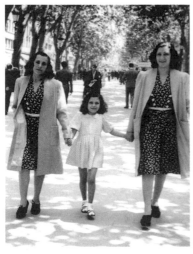

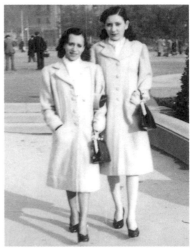

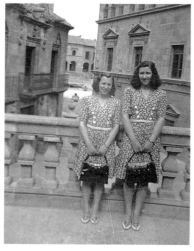

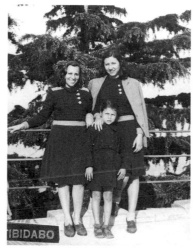

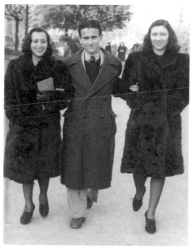

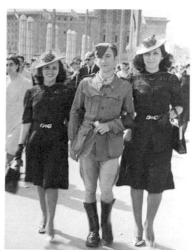

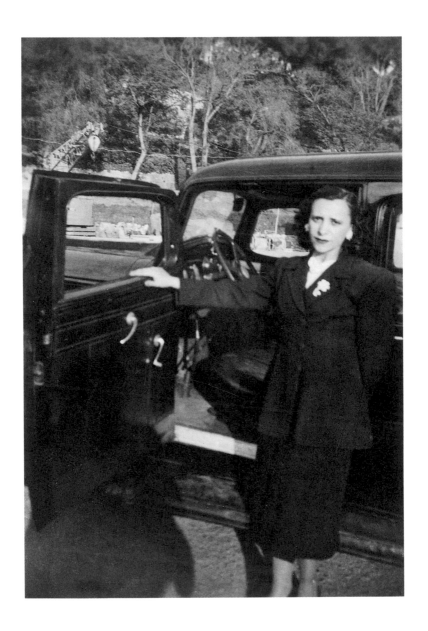

IT'S THE PERSONAL

STORY

...

. . .BEHIND THE OTHERWISE RANDOM PICTURES THAT MAKES IT SO MEANINGFUL.

MY SISTER / ONE IMAGE

MY SISTER

At first sight *My Sister* (2002) seems an ordinary home movie. Brother and sister are playing table tennis in the garden, with the mother intervening now and then. The film is styled in the warm brown and orange tones of the seventies. Their movements are adapted to the whipped-up, repetitive rhythms of Ryuichi Sakamoto's music. Nothing seems able to disturb the idyll; only the music suggests something ominous, until suddenly we are told that the girl, Kessels's sister, was killed in 1977, shortly after the movie was filmed. This unexpected information causes a shiver to run down your spine and makes the sounds, which are like children's voices, in Sakamoto's composition extra cruel.

The film *My Sister* was part of the *Loud & Clear* project and a collaboration between Marlene Dumas, Ryuichi Sakamoto, and Erik Kessels.

Page 185: *My Sister* (video), in *Five Strange Family Albums*, Le Bal, Paris, 2011.

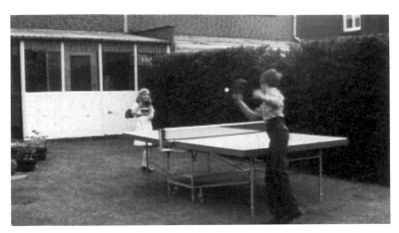

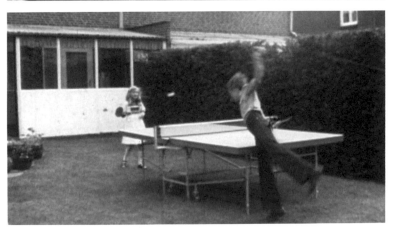

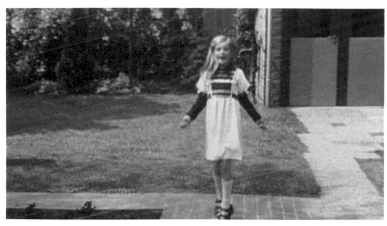

ONE IMAGE

The death of his sister when both were a young age has had a big impact on Kessels. After this tragedy, his parents started looking for the last image of her. This process helped them with their grief. They found it and cropped the image in such a way that the focus was totally on her. They enlarged it and had it framed. Ever since, this photograph has hung in their living room.

One Image (2016) is an exhibition about Kessels's sister and it consists of this one image only. It shows that a seemingly random image can have a huge importance, despite its quality and how it's taken. You need to slow down and take the time to learn about the story before you are able to see it.

SHINING IN
ABSENCE

A photobook without any pictures. *Shining in Absence* (2015) was made in honor of Frido Troost, the photo historian who passed away in 2013. It would be impossible to capture the diversity of Troost's knowledge and interests in just one book. That's why Kessels decided to focus on something else, namely that which is no longer there. Graceful, thoughtful captions are sometimes accompanied by carefully ruler-drawn lines. A plastic folder battered by age was once used to protect the photo. Now it only shows a vague imprint of what seems to be four sisters posing next to each other. The contrast between the carefulness that was once used to handle and preserve these photos and the way they seem to have disappeared couldn't be more striking. The absence of the obvious forces you to search for meaning.

Pages 204–5: *Shining In Absence*, FOAM, Amsterdam, 2015.

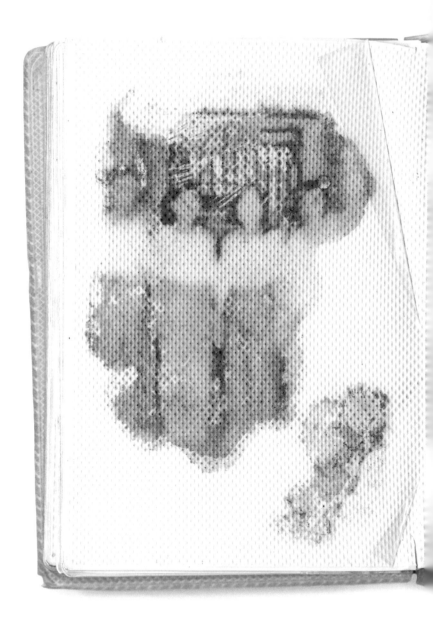

На память
дорогим Тане, Юре и
детям от нас.
Феодосия, Воли.

These Highland Cattle were bought in Arbroath
and trained in record time by VINICKY SMAHA
for a Billy Smart's Circus tour of Scotland
where, predictably, they were a huge success.
The Bovine lady kneeling (centre) is "Blondie"
who quickly established herself as leader of
the herd.

Johnny the Bactrian Camel member of the Billy
Smart's Circus "Exotic Groups" provides a
living obstacle for the four Zebras, Saida,
Fatzua, Nerida and Jamma, to leap over at the
end of their act, under the direction of
RUDI JURASCHAT.
These exotic groups have always been very
popular in European countries and few
Continental Circuses are without one.

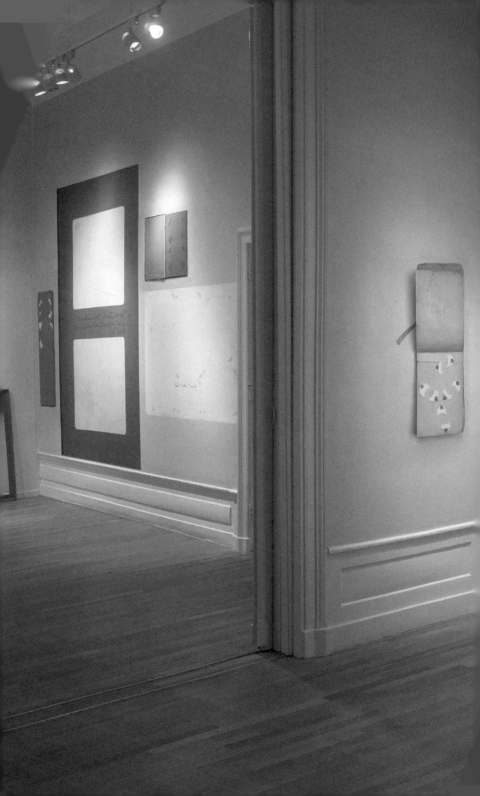

T. A. P.

AT

M. A. G.

MEANS

TAKE A PEEK

AT

MY ADORABLE

GRANDCHILDREN

IN ALMOST EVERY PICTURE

5

in almost every picture #5 (2006) is a new story told through the camera of an adoring family capturing the beauty of their photogenic dog. The photographs commemorate a visual love affair that takes place over many years. Even when people or other pets enter the images, our eyes are continually drawn to this lovely dog, a Dalmatian, whose appearance always steals the show. As if working with a model, the photographer took steps to experiment with film stock in a rather professional exercise to see whether the dog was better shot in black and white or in color. And yet, it probably became clear, due to the abundance of color shots, that her black-and-white coat was more outstanding in a world of hue.

We often think of beauty as rare. But in photography, if it's possible to have one perfect image, why not try for another one? The multiplication of beauty in no way diminishes the rarity of it. We can increase the impact. With photographs we can revisit at any moment the great span of what delights our eyes and our hearts in almost every picture we make.

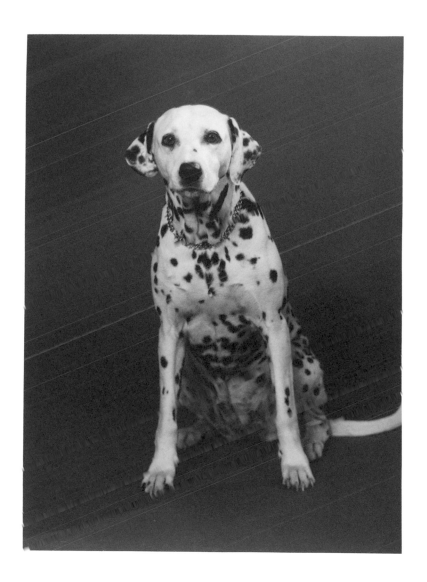

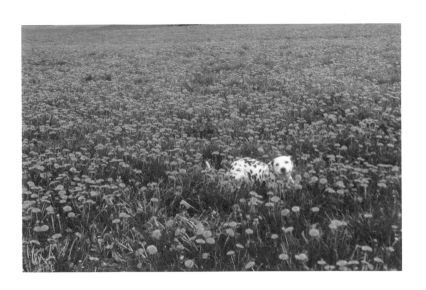

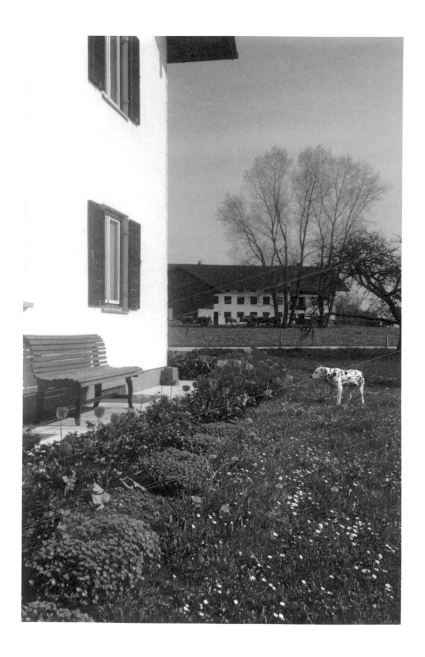

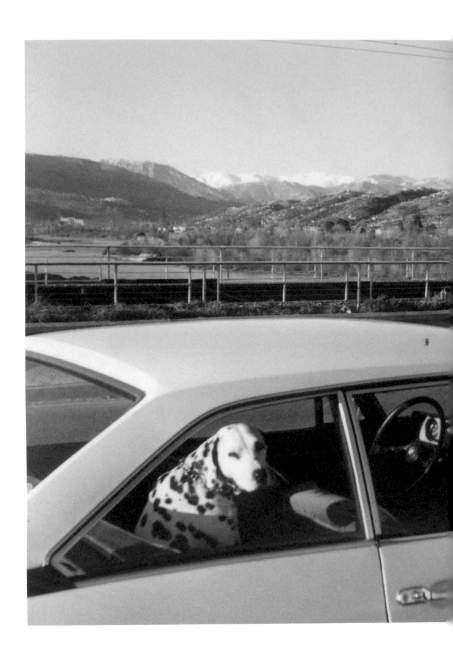

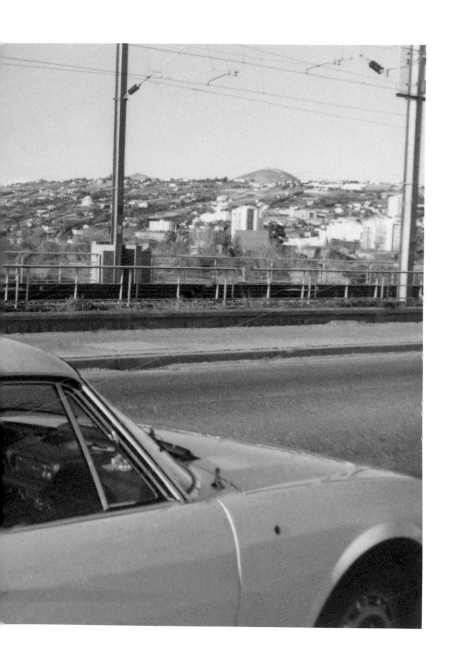

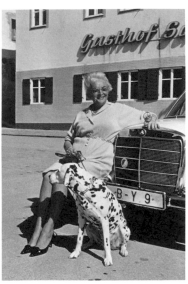

 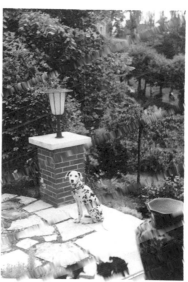

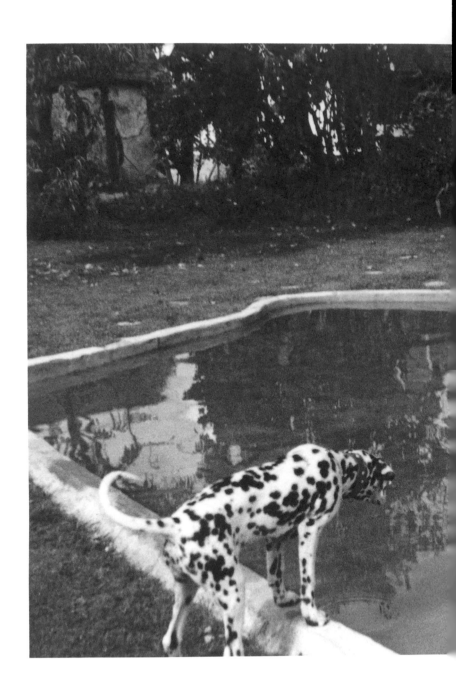

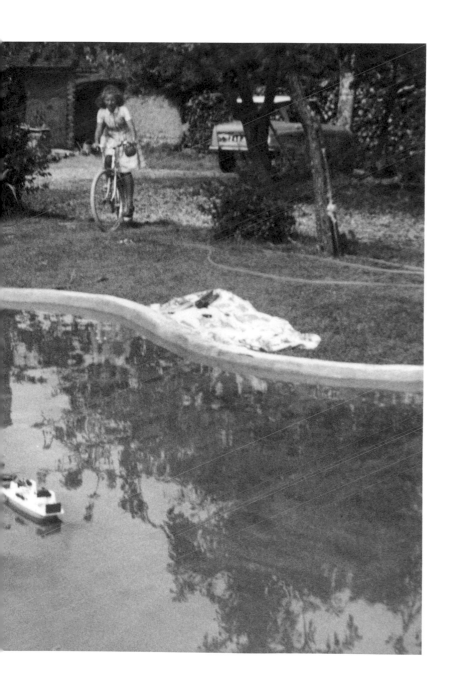

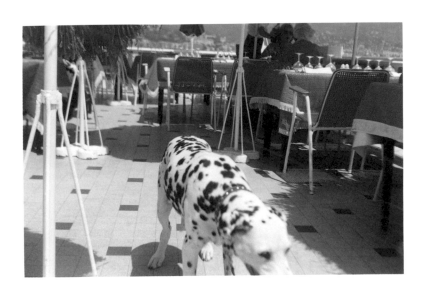

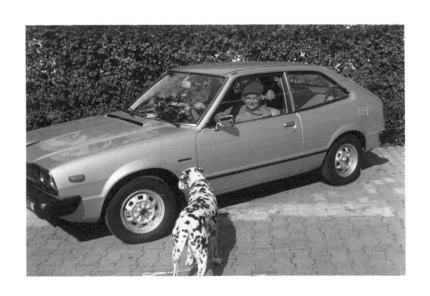

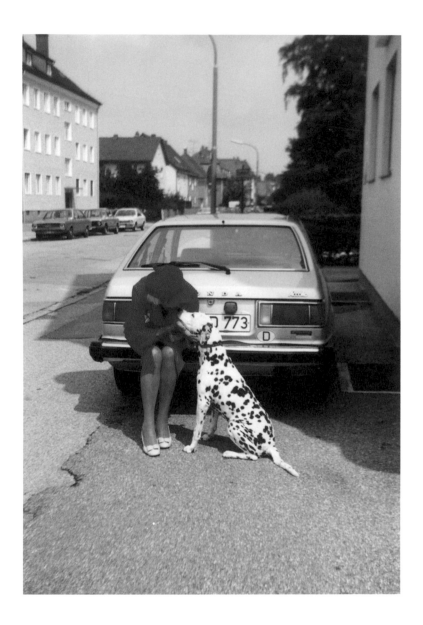

In the eighties, television reached China in a big way. And much like the first appearance of TV in the West in the fifties and sixties, those lucky enough to own a television proudly displayed their box, using it as a status symbol. You can imagine the joy and curiosity TVs brought their first owners. For this reason, photographs of people and their televisions began appearing around China. Each showed a TV and its owner, posing as if with a spouse. Found in a market in Beijing, *ME TV* (2014) shows a woman in her late sixties, always in an identical pose. In fact, the only thing that changes is her outfit. Even her pinkie finger remains static and strangely angled, in shot after shot. It's an extraordinary small photographic series, made most likely by a husband and his wife over a short period of time—a couple documenting the arrival of a new television set and doing it in a way that verges on a work of conceptual art.

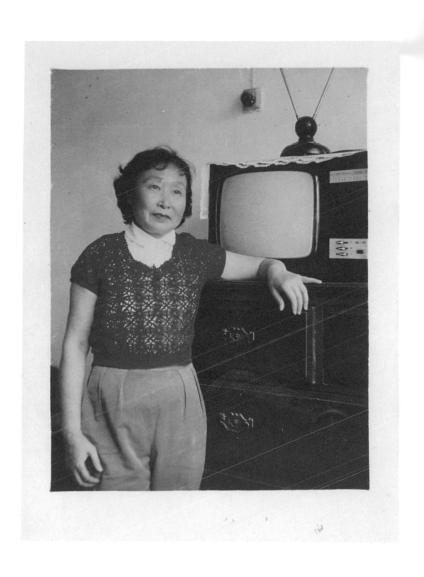

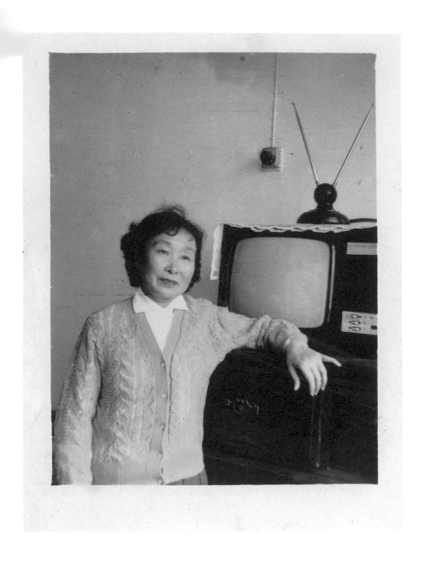

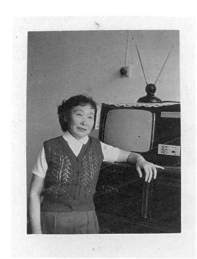

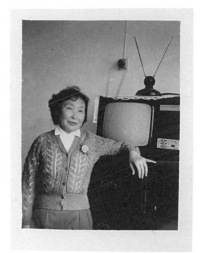

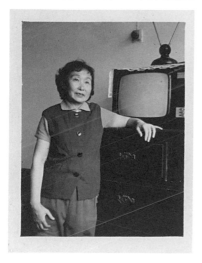

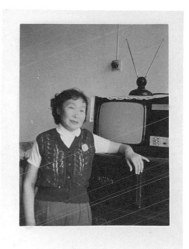

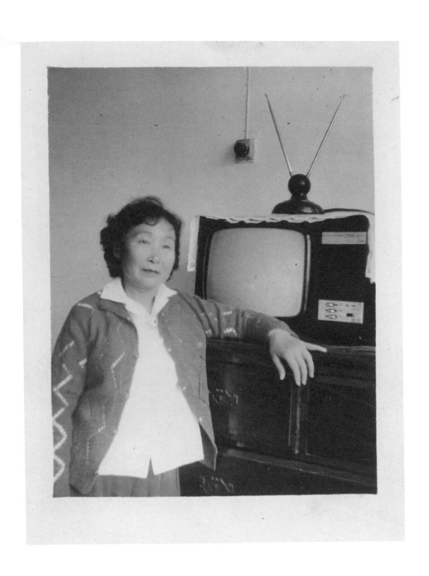

IN ALMOST EVERY PICTURE

6

almost every picture #6 (2007) is the story of an anonymous woman who photographed herself almost every year for most of her life. The collection consists of black-and-white photographs, mainly shot in an old-fashioned photo booth. These tiny images together circumscribe the life of an everywoman, a person whose span roughly covered the most turbulent century in human history. But in almost every picture she looks quiet and calm, the photo booth insulating her from world wars, moon landings, presidential assassinations, and a time when it seemed humanity found new ways to extinguish itself every six months. Why did she undertake this project (if she even thought of it as a project)? As a way of preserving her personality, of proving to herself that she'd lived? Vanity? Insecurity? Pride? We fill in her life with our interpretations, and that makes the experience all the more pleasurable . . . Because, in the end, what we think about her says as much about ourselves as it does about the subject.

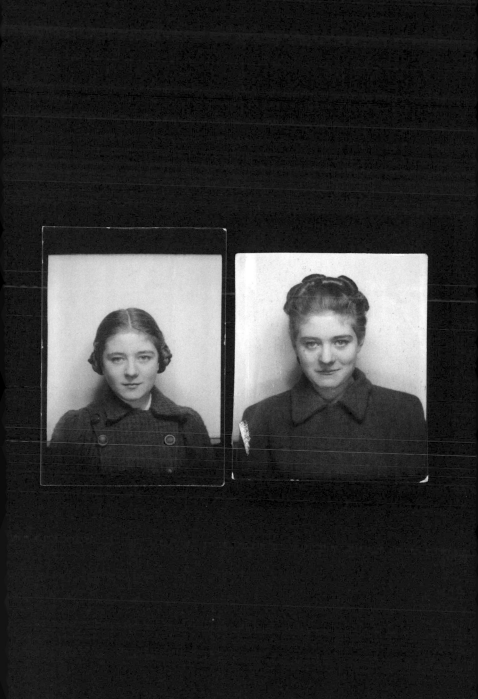

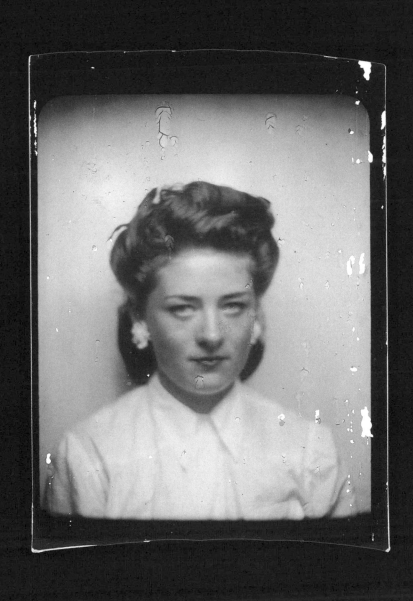

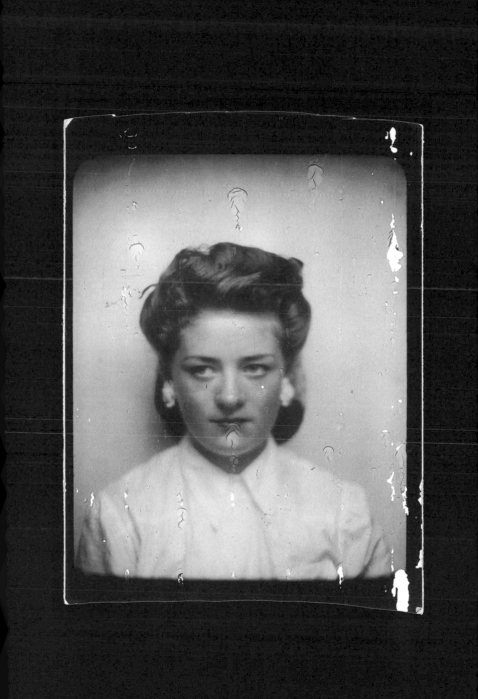

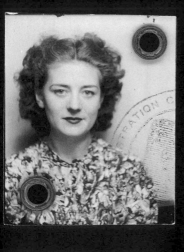
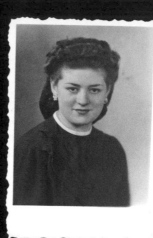
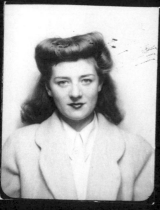
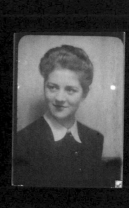
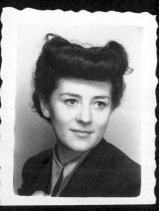

UNFINISHED
FATHER

Kessels's project *Unfinished Father* (2015) is a personal one. His father suffered a stroke and has barely spoken or moved since. Prior to this, he was extremely active. His projects included restoring examples of that Italian icon, the Fiat 500 (or "Topolino"). Before his stroke, he'd completed four such restorations and was working on a fifth, the half-finished carapace of which was left abandoned at his home.

This car came to represent Kessels's father, unfinished, and forms the basis of this project. Kessels transported his dad's last Topolino to Reggio Emilia and to London and presented it alongside intimately detailed images his father made to document its restoration. This work is about a man who—like his vehicle—will never be complete, but will remain forever interrupted. The unfinished Topolino is the reverse of his father's situation in life: he was a man who didn't like to leave things undone, who saw them to their end. We can attempt to control our circumstances, but in the final analysis they control us.

Pages 245, 248–49, 250 bottom: *Unfinished Father*, Fotografia Europea, Reggio Emilia, Italy, 2015. / Pages 250 top, 251, 252, 253: *Unfinished Father*, in *Deutsche Börse Photography Foundation Prize 2016*, The Photographers' Gallery, London, 2016.

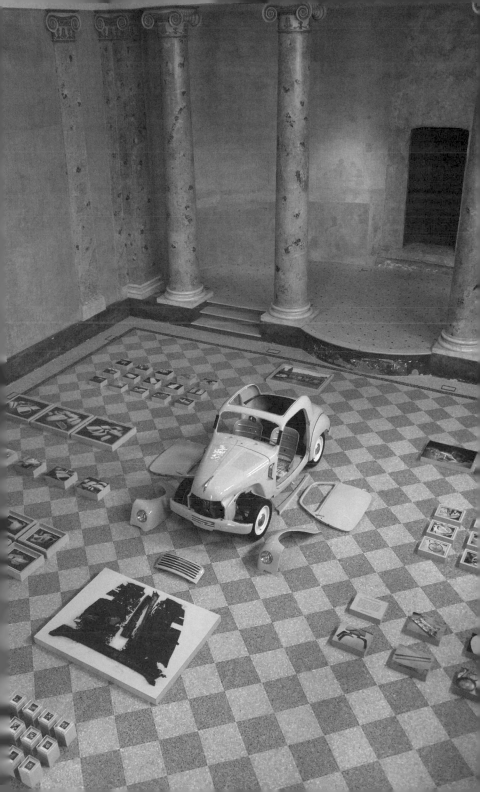

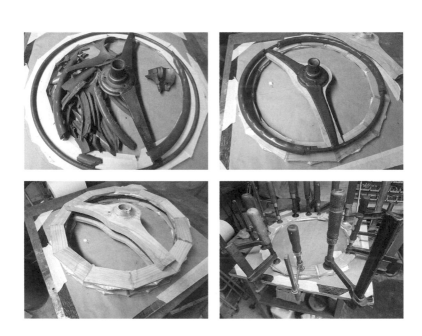

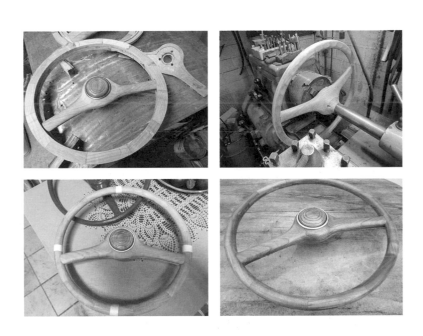

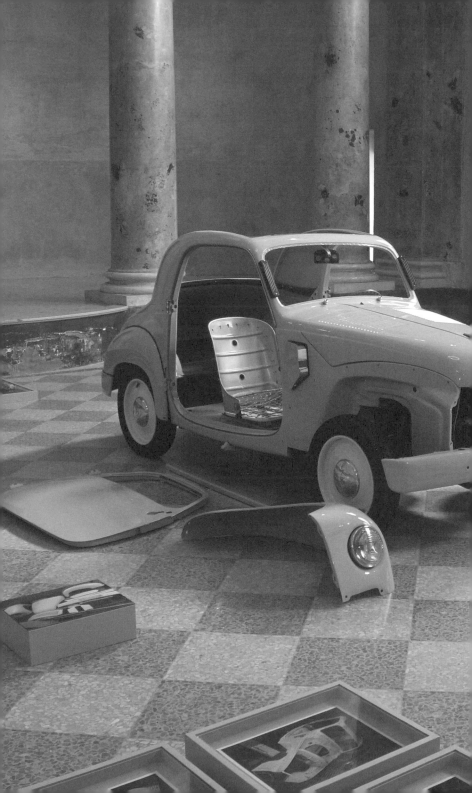

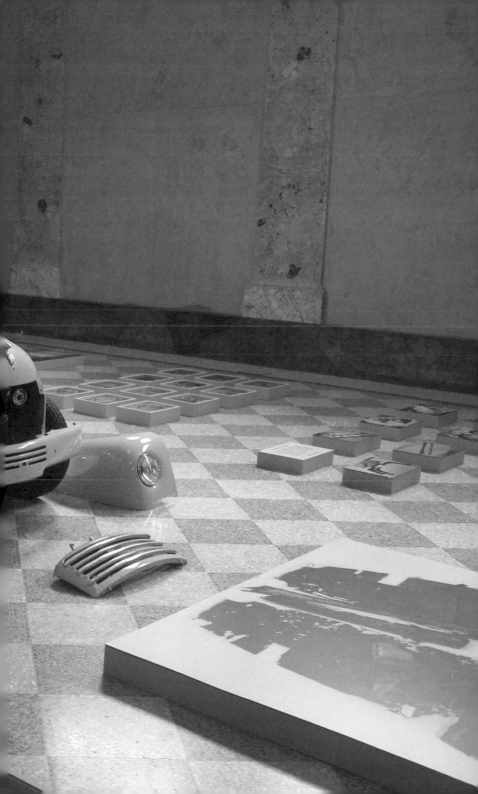

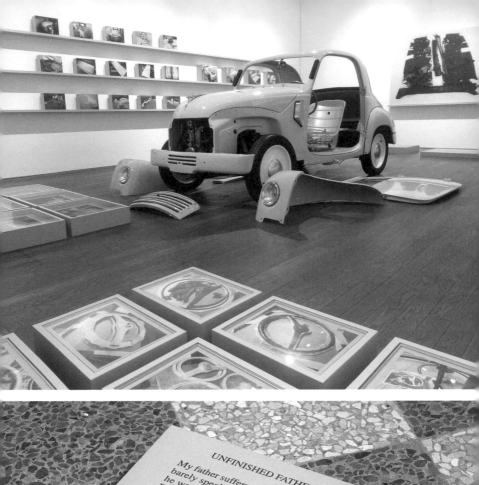

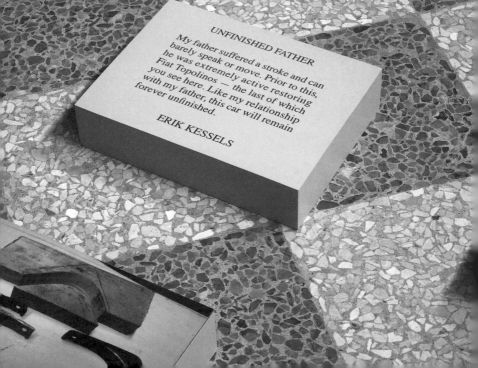

UNFINISHED FATHER

My father suffered a stroke and can barely speak or move. Prior to this, he was extremely active restoring Fiat Topolinos — the last of which you see here. Like my relationship with my father, this car will remain forever unfinished.

ERIK KESSELS

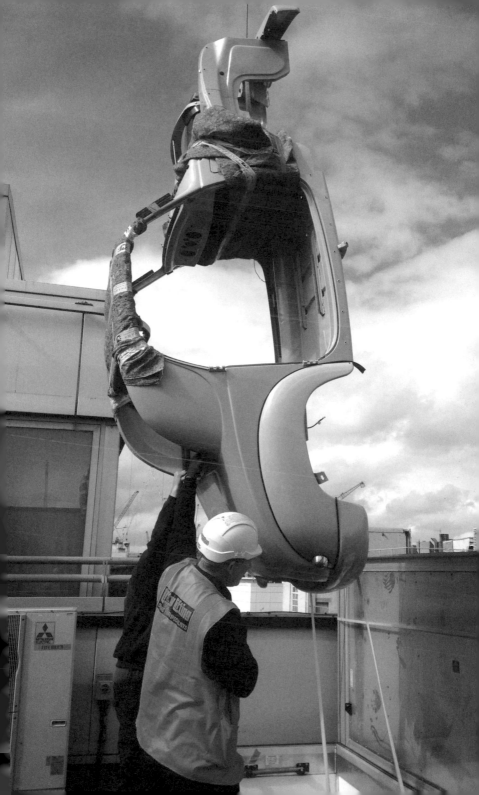

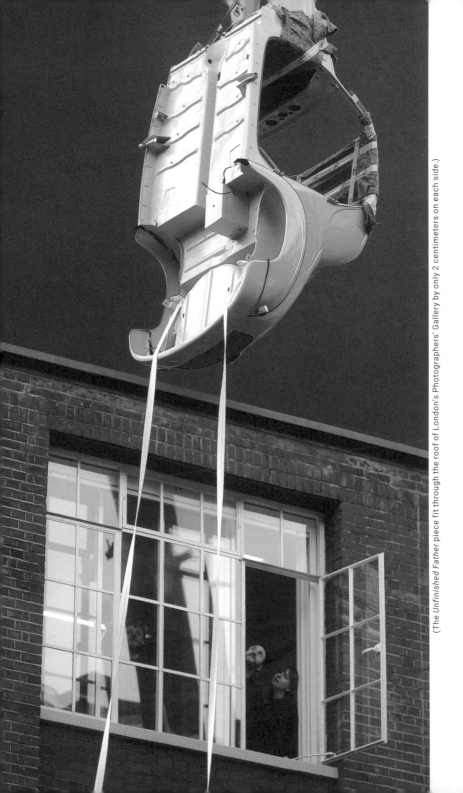

(The *Unfinished Father* piece fit through the roof of London's Photographers' Gallery by only 2 centimeters on each side.)

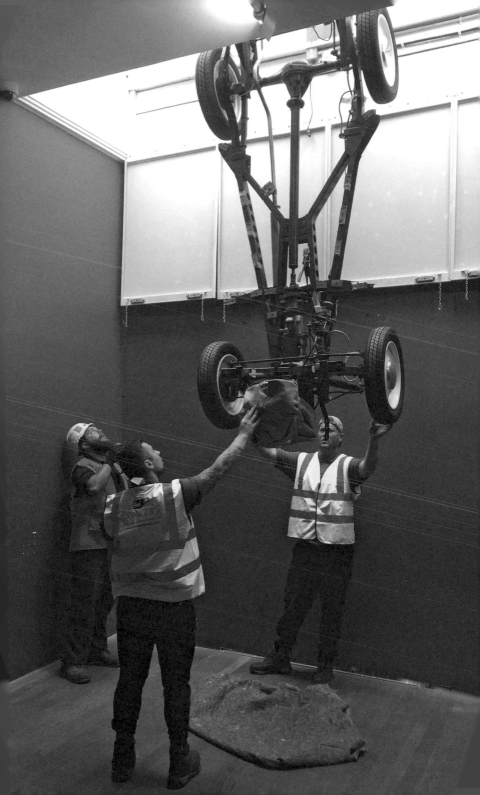

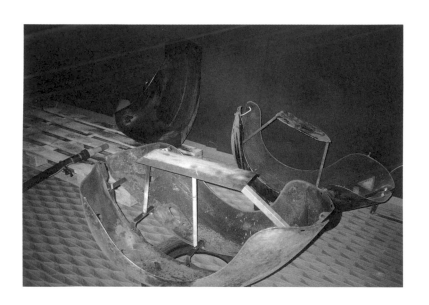

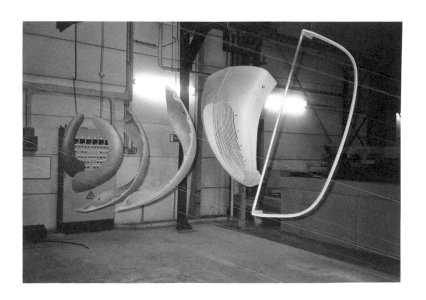

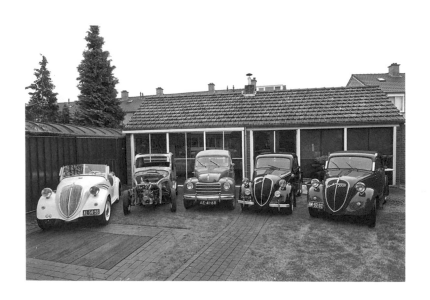

IN ALMOST EVERY PICTURE

7

in almost every picture #7 is the story of Ria van Dijk, a
Dutch woman whose life is seen from the point of view
of a fairground shooting gallery. The chronological
series begins in 1936, when a sixteen-year-old girl from
Tilburg in Holland picks up a gun and shoots at the
target in a shooting gallery. Every time she hits the
target, it triggers the shutter of a camera and a portrait
of the girl in firing pose is taken and given as a prize.
And so a lifelong love affair with the shooting gallery
begins. This series documents almost every year of the
woman's life (there is a conspicuous pause from 1939
to 1945) up until present times. It's a biography of one
woman's life from an unusual perspective, one that
allows us to witness the times she lived in, and also acts
as a revealing look at the changing face of photography
through the decades.

 After the book was released in 2008 she kept
making her pilgrimage to the shooting gallery. In 2016
the book was reprinted with eight additional shots in
honor of her eightieth year of hitting the bull's-eye.

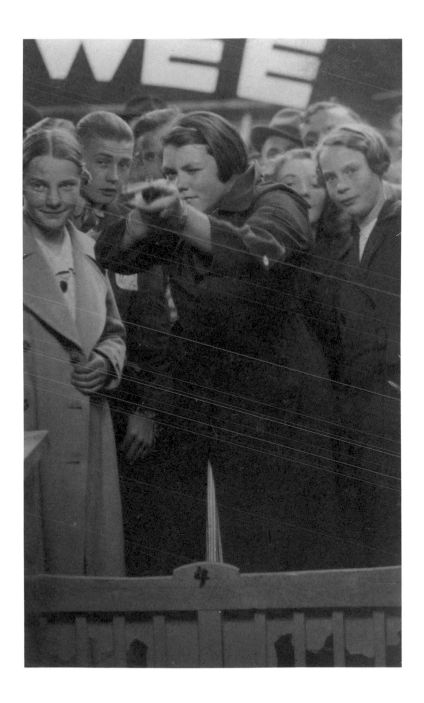

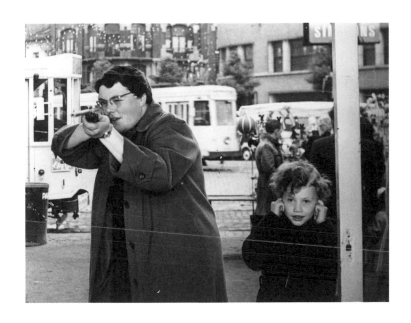

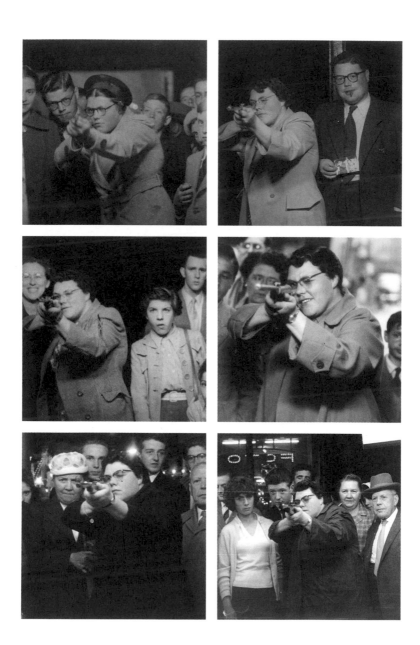

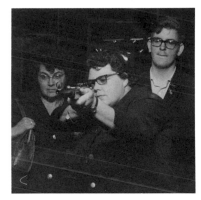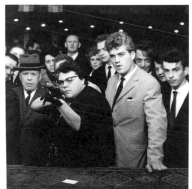

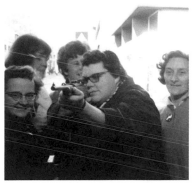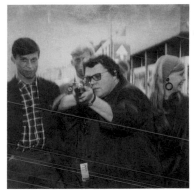

(On July 22 2016, Ria van Dijk shot for the eightieth year at the fun fair. With a little support from the authors of *in almost every picture #7*, she shot a bull's-eye once again.)

Een voltreffer

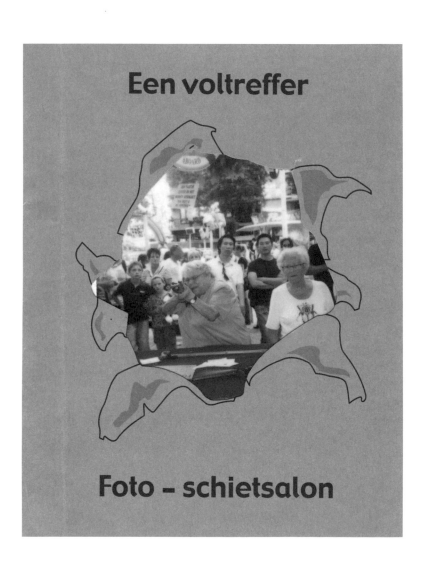

Foto – schietsalon

24HRS
OF
PHOTOS

We're exposed to an overload of images now-adays. This glut is in large part the result of image-sharing sites like Flickr, networking sites like Facebook and Instagram, and picture-based search engines. Their contact mingles the public and private, with the very personal being openly displayed. With the printing of all the images uploaded in a twenty-four-hour period, the feeling of drowning in representations of other peoples' experiences is visualized. The installation *24hrs of Photos* (2011) is presented as a mountain of photographs amassed in bulk. This device randomly materializes the number of files uploaded in a single day and posted on Flickr, a website for sharing photos. Some 350,000 prints are within easy reach of visitors.

(A priest in Arles, France, spontaneously blessed the work *24hrs of Photos* in his chapel.)

Page 285: *24hrs of Photos*, Les Rencontres de la Photographie, Arles, France, 2013. / Pages 286–87: *24hrs of Photos*, FOAM, Amsterdam, 2011. / Page 288: *24hrs of Photos*, Festival Images Vevey, Switzerland, 2014.

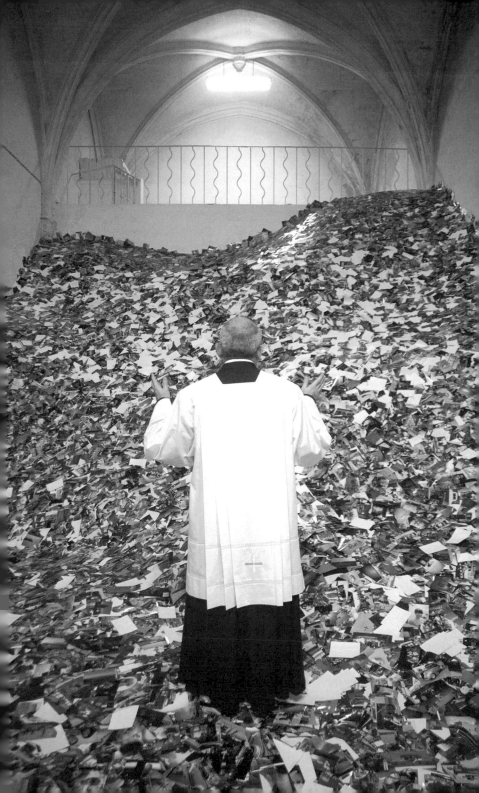

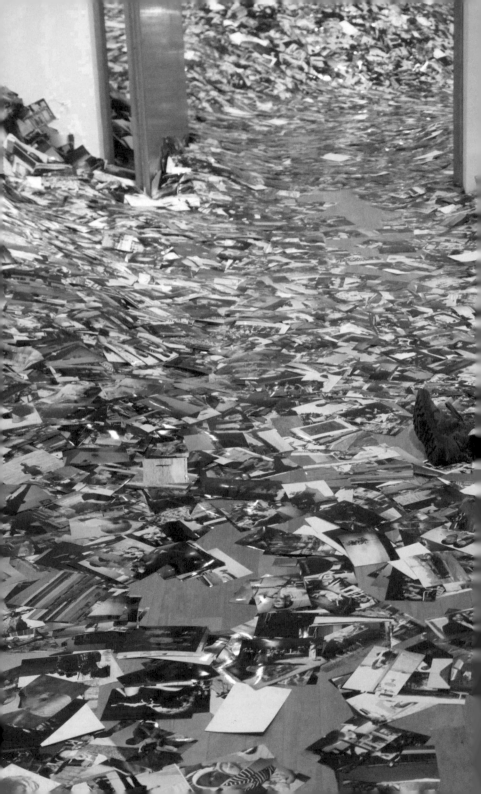

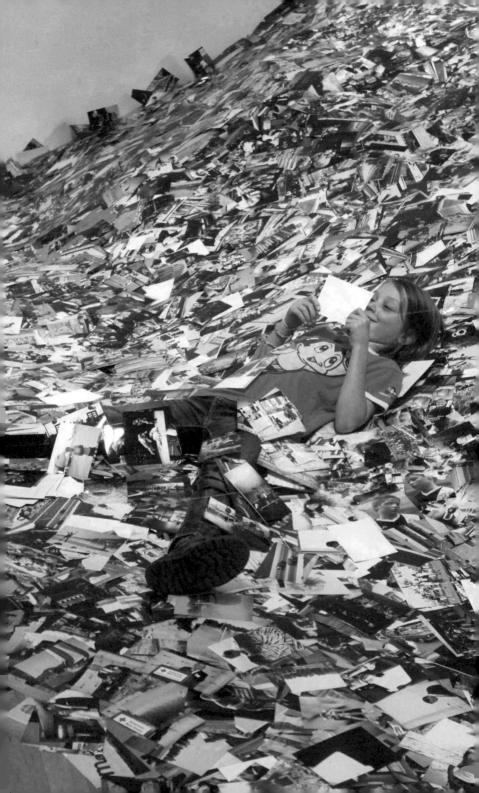

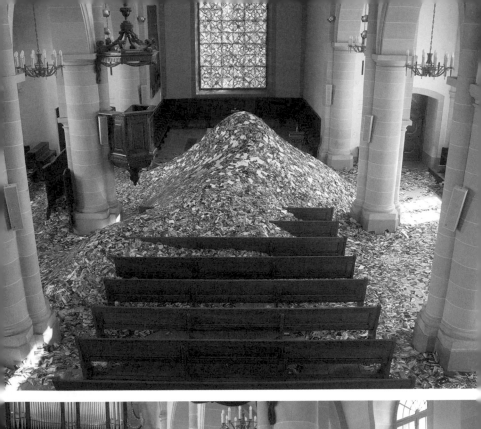
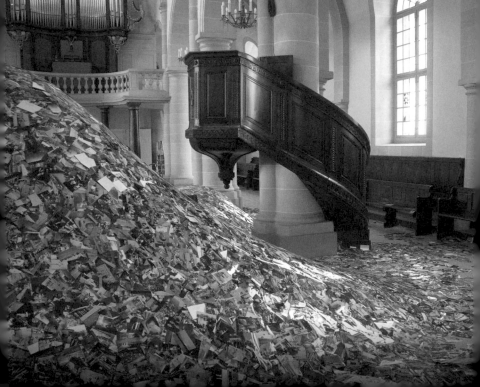

THERE
IS SO MUCH
AVAILABLE
THAT WE HAVE
TO CHOOSE

. . .

...

WHAT WE

SEE

WHAT WE

HEAR

AND WHAT WE

READ

●

IN ALMOST EVERY PICTURE

8

in almost every picture #8 (2009) is one of the earliest successful photo blogs, a site documenting the story of Oolong, a Japanese rabbit whose unusually flat head made it ideal for balancing objects. Starting in 1999, hundreds of images were posted by Oolong's owner, Hironori Akutagawa, each showing this otherwise ordinary creature with an unusual item placed squarely on his skull. The motivation behind these portraits remains unknown: an obscure comment on the human world from an animal perspective? Or simply a unique record of friendship between man and pet? Whatever the case, Oolong's site became a pioneer in the blogging field, part of a wave that helped democratize images in a way that would come to define photography in the Internet age. For the first time, widespread access to the web made it possible to access pictures previously only available to those willing to search out the quirky, beautiful, and strange at specialist stores and galleries.

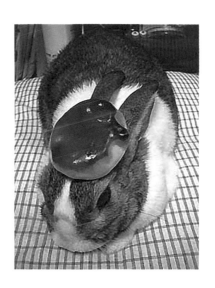

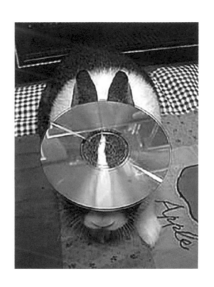

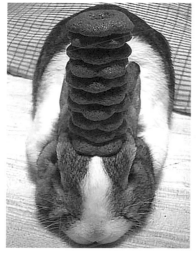

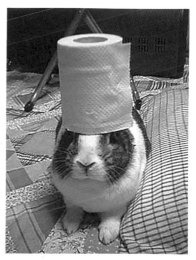

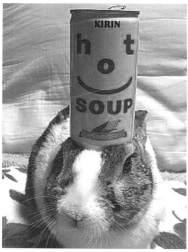

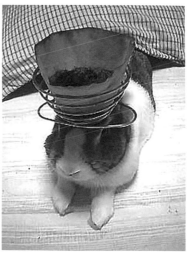

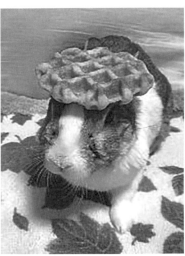

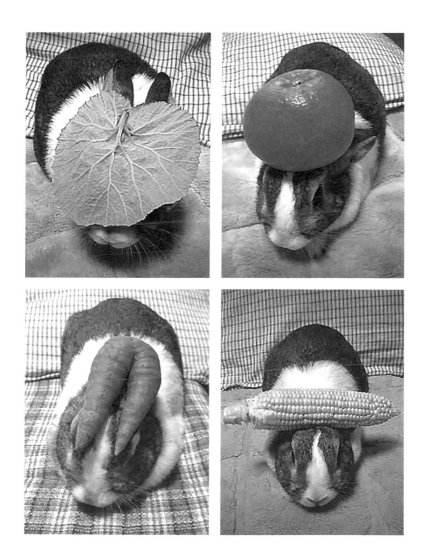

THE
INSTANT
MEN

19 PHOTOGRAPHS
OF PHOTOGRAPHERS

Numerous European cities are familiar territory for these men equipped with Polaroid cameras and a bunch of bright flowers in search of drunken subjects. Many of us, at one time or another, have had our picture taken by the Instant Men, a blurred reminder of a blurry night. Nineteen portraits of the Instant Men of Amsterdam are preserved in this publication (1999), which is an ode to these photographers whom often make more photographs in one night than any professional photographer would in a month.

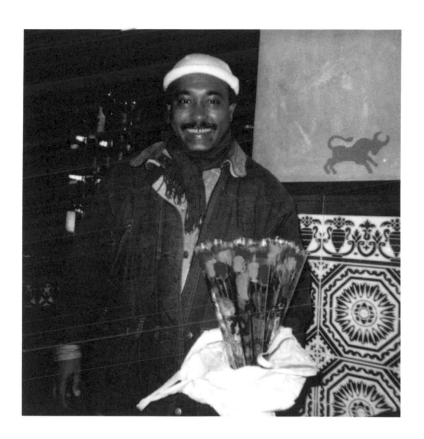

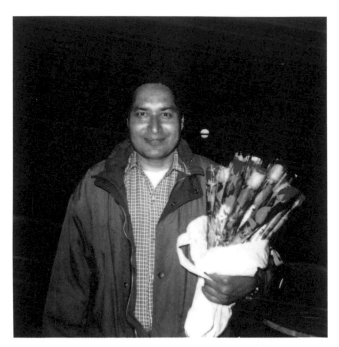

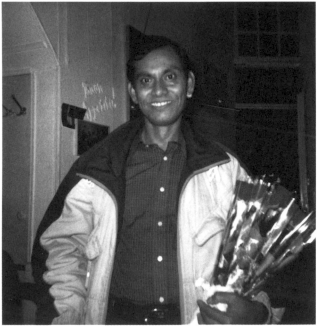

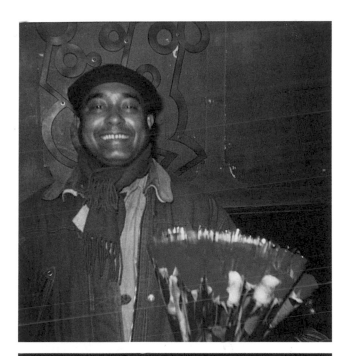

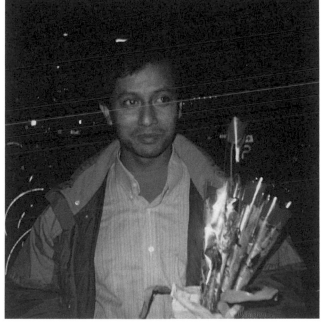

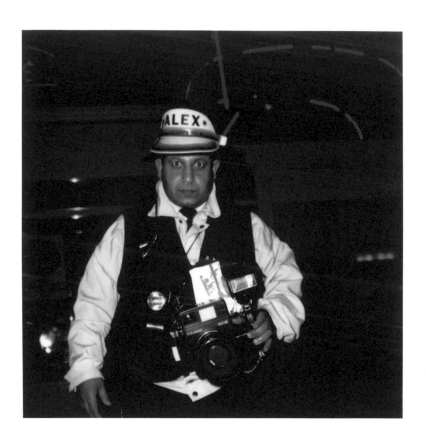

BANGKOK
BEAUTIES

Beauty captures the eye as well as the imagination. There is something naturally alluring and distracting about loveliness; something in its purity, its naïveté, its promise, and its hopeful inspiration. We all tend to gravitate with passion toward the ideal.

In *Bangkok Beauties* (2007), Kessels provides a look at a specific photographic series that depicts attractive women during a beauty contest some time ago. Here we see the contestants displaying themselves in such a way as to be judged by their poise, their posture, and most of all by their appearance.

The photographs have become even more precious and lovely in their decay. Over the years, the pictures have deteriorated. They've been scratched and suffered weathering, all of which serves to enhance their beauty both as images and as objects. In fact, we can hold these rescued beauties and see them front and back, thereby joining in the admiring contest that continues even still.

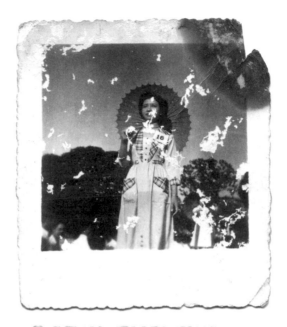

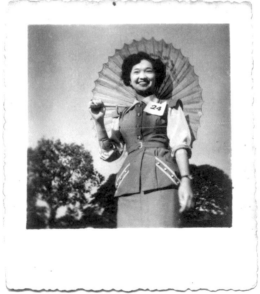

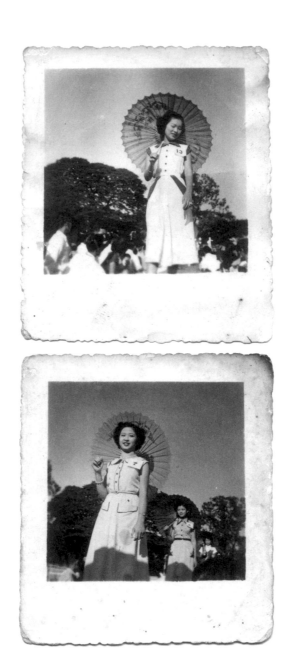

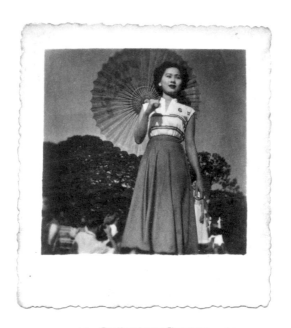

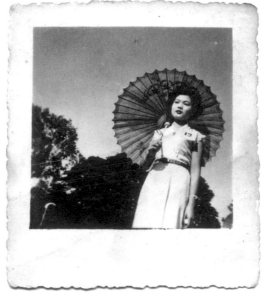

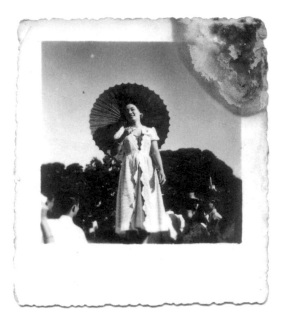

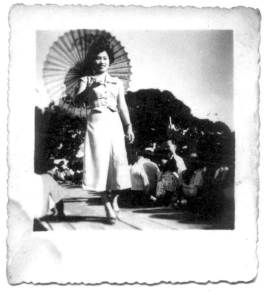

ERIK KESSELS – (I'M WITH STUPID)

SIMON BAKER

*I really don't consider myself an artist. I make art, but it's
a job . . . this is one profession in which I can be a little
bit stupid, and people will say, "Oh, you are so stupid,
thank you, thank you for being so stupid."*

—Maurizio Cattelan

*Amateurs . . . never know what they might end up with,
and they don't particularly care. Nor should you.*

—Erik Kessels

In 2003 the French writer and critic Jean-Yves Jouannais
published one of the most important revisionist histories
of art to have emerged in the past fifty years. It was called
L'idiotie (Idiocy) and true to the form of the kinds of art
with which it was concerned, it was mostly ignored and
misunderstood. Primarily it was ignored because no one
translated it into English, and the Anglophone world is far
too lazy and arrogant to take untranslated French books
seriously: they, it is assumed, like public safety warnings on
Japanese cigarette packets, are clearly not intended for us.
But make no mistake, Jouannais's book is full of important
information. It may not save your life, but neither will
learning to read warnings about smoking in kanji.

The gist of *L'idiotie*, to summarize with brutal brevity,
is that there is (and has been) a radical third way for art
production that has been dangerously misunderstood and
underrated. Looking back to the early twentieth century
from today's vantage point, Jouannais makes clear, it is no
longer necessary to posit the binary logic of creative genius
(Picasso) versus nominalist genius (Duchamp). Rather, it
has always been possible, in Jouannais's opinion, to avoid
the pitfalls of predictable (and successful) art by engaging
fully in stupidity, loving mediocrity, and flirting with
failure: "art did not become modern," he claims, "until

idiocy became its generative principle." This strategy (or nonstrategy in most cases) also has the added benefit of dealing with, and resisting, the postmodern disappearance of the author into the work: "Idiocy in art," he says, "itself a voluntary idiocy, revindicated and instrumentalized, constitutes . . . a manner of resisting disappearance." But that's enough bad translation of a brilliant book. Don't be an idiot; find a copy, look at all the pictures, and then find a French person who'll tell you what the words say . . .

Anyone who knows Erik Kessels (or his work) should have bells going off in their heads by now. We all know (or at least suspect) that Kessels is not stupid, but then again, he seems to have the ability to do deeply idiotic things in the pursuit of a kind of hard-core resistant art production (up to and including photographing his own penis and then hiding it in a book of thousands of penis photographs). But as Kessels himself writes in his recent book on failure: "If you're anything like me, you're called an idiot at least once a day. And that's OK. Because making mistakes, flirting with disaster and pure, outright failure is how you will get better. Without it, you're stuck in a zone of mediocrity." (Jouannais, incidentally, would probably have a problem with this, as he sees mediocrity itself as containing a rich vein of usually untapped creativity: truly stupid artists, perhaps, should have no need to "get better.")

There is, however, a dumb core of Kessels's practice. Although there is probably no sense in which he'd ever feel licensed, like Maurizio Cattelan, to be "professionally stupid" as an artist. The wide range of Kessels's activity, from advertising to art direction, graphic design, curating, collecting, and so on, is insurance against the notion of simply being an *artist* (or even more simply, a photographer). And even the small-scale photobook world, which Kessels has made his home, sees him as everything along the sliding scale from artist/producer to publisher/collector. The dumb core, then, can be found in Kessels's ability to bracket out and suspend these categories in such a way that normative

notions of production and consumption are interrupted or suspended. And this, at a time when the ubiquity of appropriated content has made it almost completely impossible to tell who the next person to stumble from photographic stamp collector to conceptual artist is likely to bc. There are brilliant stars in the Milky Way of found imagery (like Kessels's friend and occasional collaborator Thomas Mailaender), but they're horribly outnumbered by orbiting lumps of rock dying to be reclassified as planets.

But Kessels was not just (or maybe not even) onc of the first to mine the infinitely deep shafts of mediocrity constituted by the photographic albums of ordinary people. He seems always to have had the inexplicably positive attitude of a delusional alchemist: certain than he will succeed, where all others before him have failed, in turning giant piles of unremarkable dross into pure gold. In and of themselves, the photographs from which much of his work is assembled are unutterably dull, miserably inadequate, obstinately occupying the space reserved for things diametrically opposed to art. But the apparently impoverished nature of this material is magically reversed by the relentless optimism of Kessels's dumb humor. Because he is determined not to care about individual images at the level of meaning or value, they become transcendent symbols of potential mobility and the mystical power of failure and stupidity to reverse value systems. This was particularly evident in the works selected for the exhibition and book *Failed It!*, where Kessels shifts deftly from finding strange pictures that make us think or make us laugh, to finding other people who have already done the dumb legwork for him. Everywhere in Kessels's work the normative logic of production is replaced by something better: something that refuses to obey the various indices of value that artworks love to be measured by. These include (but are not limited to) originality, uniqueness, expense, size, intention, formal organization, aesthetic sophistication, and even beauty.

We could leave Kessels here, staring at us like a lost puppy from the other side of the border between art and rubbish. But Kessels, one suspects, would never abandon a lost puppy (even one that mysteriously failed to register on photographic film), just as he would never suffer the life of an image to be prematurely cut short. Among his most recent work, *Unfinished Father* stands out, both for its raw emotional content and Kessels's evident need to take the real world seriously. Confronted by the long-term illness of his father following a stroke, Kessels constructed the installation *Unfinished Father* from parts of the vintage car his father was working on before his illness, including the photographs made in the restoration process. But even here, in the man-cave of emotional failure, Kessels makes a virtue of losing the plot: "we can attempt to control our circumstances," he writes, in the book of the project, "but in the final analysis they control us." Having proven, time and again, that unleashing the tsunami-like flow of global image culture is an unpredictable and risky business, Kessels finds not only that it's beyond his control, but that it has flooded his basement.

IN ALMOST EVERY PICTURE
9

in almost every picture #9 (2010) shows a family's efforts to capture their pet dog on film. Unfortunately for the photographers, the dog has very, very black fur, making him almost impossible to depict accurately. Doubly unfortunate is their camera, an old Polaroid completely unsuited to taking pictures in conditions dimmer than a desert at noon in July. So these would-be attempts to show love for a four-legged family member would appear doomed. But actually they make for rather beautiful mistakes, with the dog assuming an air of mystery and importance, made more present by his absence. Around the fringes of the canine silhouette we see details of a now vanished world, a place decorated like a set from an old movie, all wood paneling and wallpaper that would be ironic now (but most definitely wasn't then). Page after page we witness this place and its non-dog, each image an attempt to show domestic contentment in a different way. Some shots are improbably well composed, some serious, and some aim for humor, as when the owner poses to have a conversation with the dog blob while they sit on armchairs.

By the end, we wonder whether we'll ever see the doggy hero, and then—quite suddenly—there he is, revealed at the end of the book. Quite unexpectedly, we see what the fuss was about . . . Spanning many years, this epic tale of determination leaves a rousing message: be true to yourself and your dreams and one day, you shall succeed. Even if success means merely taking a decent picture of your best friend.

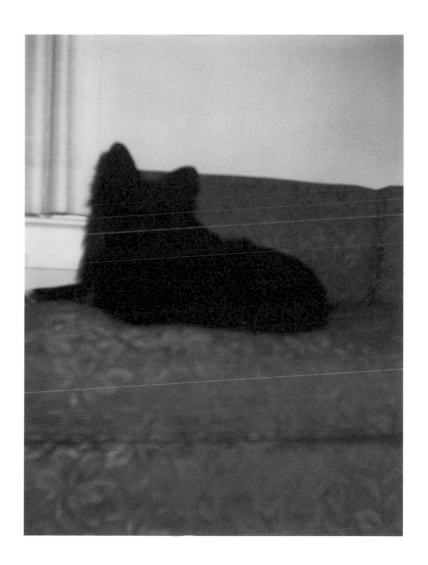

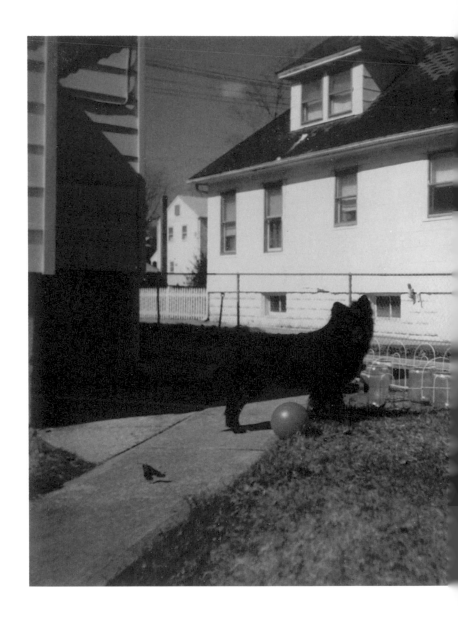

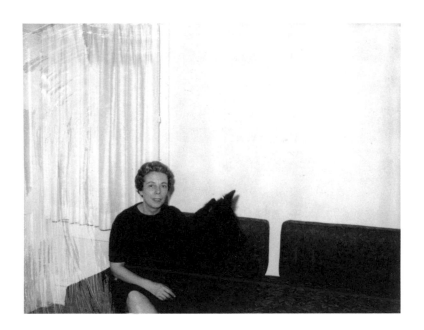

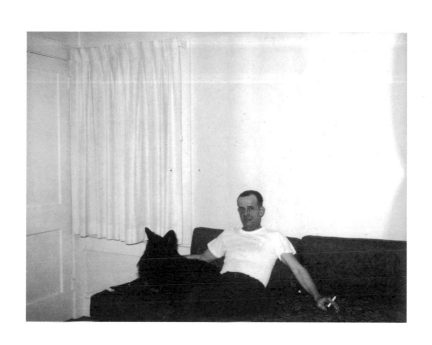

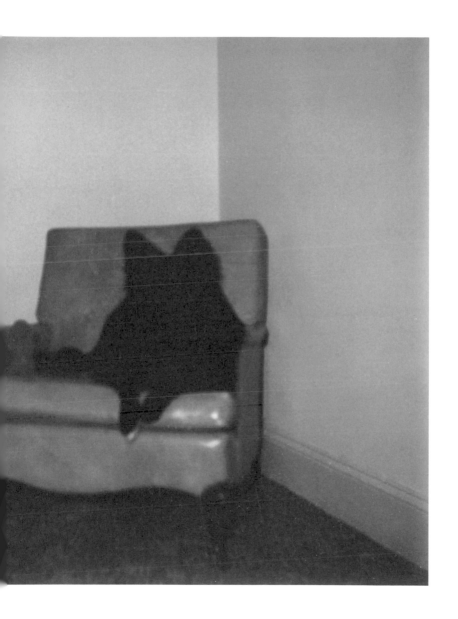

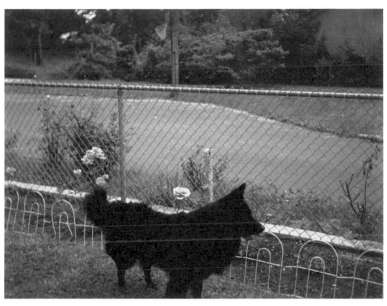

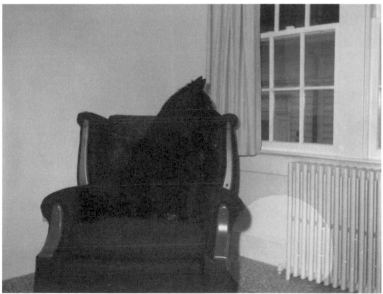

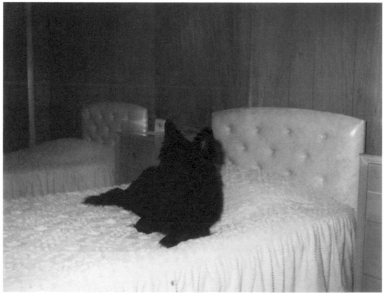

IN ALMOST EVERY PICTURE 10

The tenth edition of *in almost every picture* (2011) shows old images of pigs being bottle-fed by clients in the Montreal restaurant Au Lutin Qui Bouffe. Picture after picture, we see customers with a piglet in their laps or on their table—stroking it, holding its tail, or poised with knife and fork, pretending to eat it. Playing with their food. The series is epic, begun in 1938 and continuing over thirty-five years, every image made by local photographer Jean-Paul Cuerrier. We're confronted by a fundamental difference in attitudes, between those of our own generation, and those of our parents and grandparents. Judging by the customers' innocent smiles, the pig is a cute diversion, not a reason to call the hygiene inspectors, PETA, or CNN. Their entertainment is our animal rights abuse and we're reminded of our own relationship to what we eat. There's a second, unavoidable theme to this book: obsession. These images are repetitive, shot with little variation in angle or composition. Photographer Cuerrier is believed to have taken 250 such shots in one night. Even after the death of the project's initiator, restaurant owner Joseph McAbbie, Cuerrier continued, amassing thousands of images—most of them later destroyed by fire. That aside, there's one very obvious and very ominous question remaining: what exactly happened to the pigs?

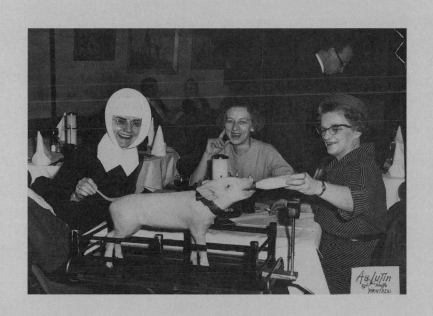

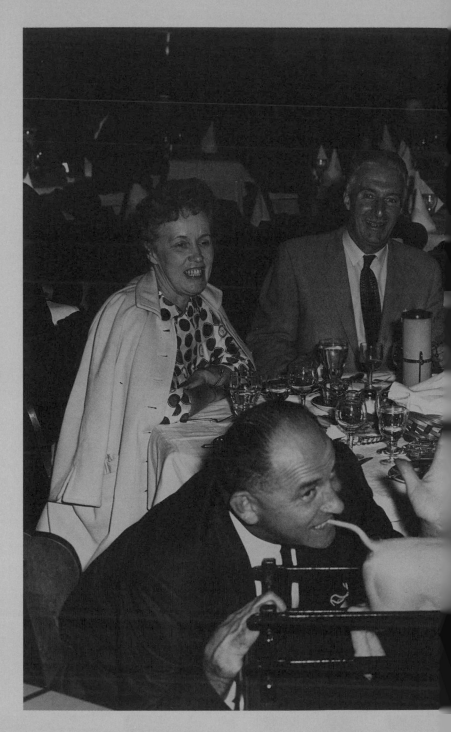

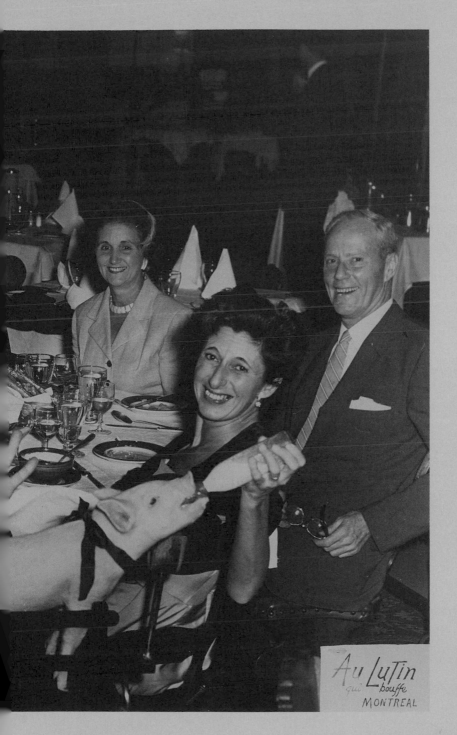

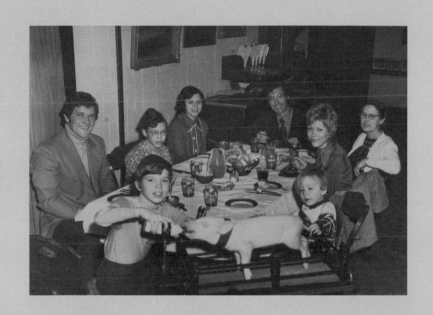

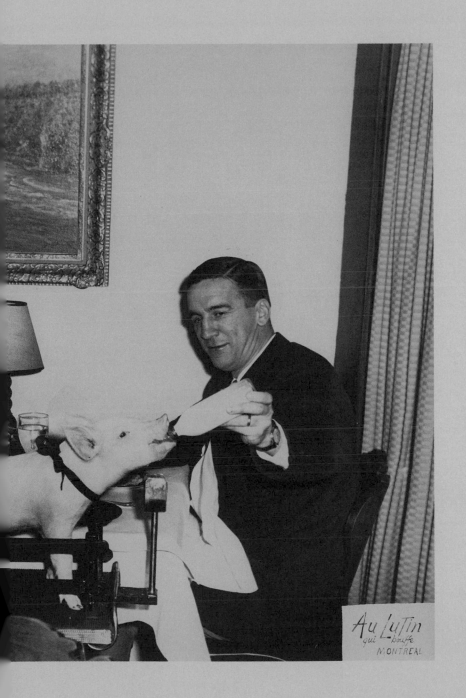

Au Lutin
qui bouffe
MONTRÉAL

343

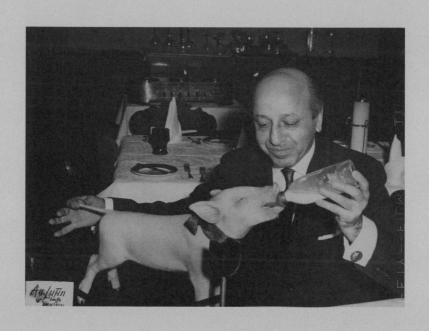

MY
FEET

My Feet (2014) shows thousands of the pictures that people upload nowadays after they have photographed their own feet. These photographs are often made out of boredom and not knowing what else to photograph. Even though the person isn't visible, the photo tells a lot about a place and situation they're in. It gives a sense of the vast expansion of imagery around us and shows one of the ways people share personal images with everyone.

Page 349 top: *My Feet*, in *Ego Update: The Future of the Digital Identity*, NRW-Forum Düsseldorf, 2015–16. / Page 349 bottom: *My Feet*, f/stop Festival for Photography, Leipzig, Germany, 2014. / Pages 350–51: *My Feet*, f/stop Festival for Photography, Leipzig, Germany, 2014.

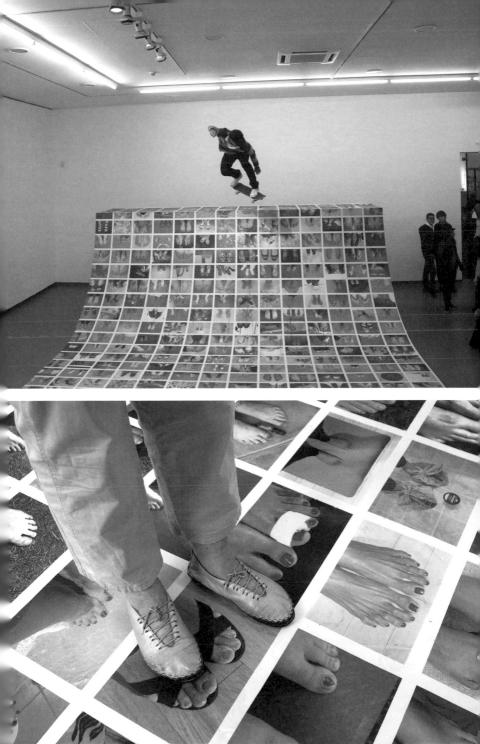

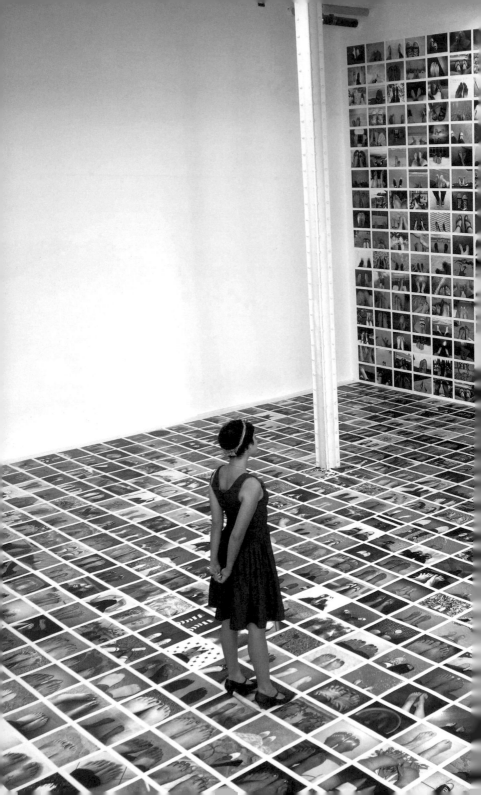

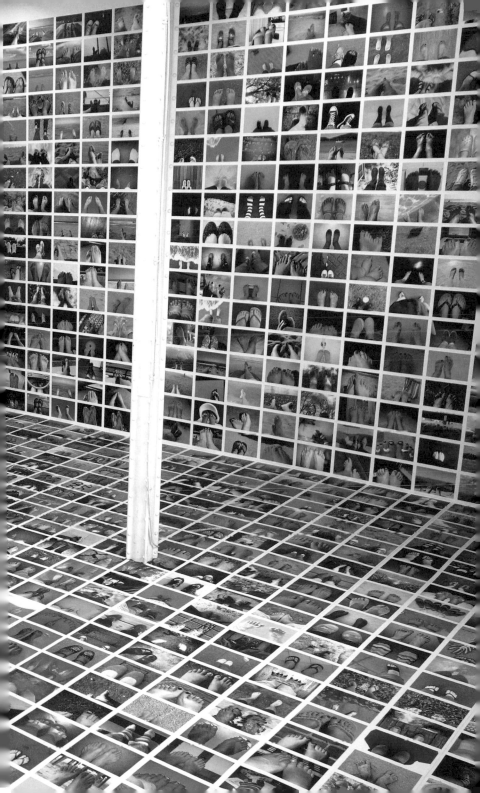

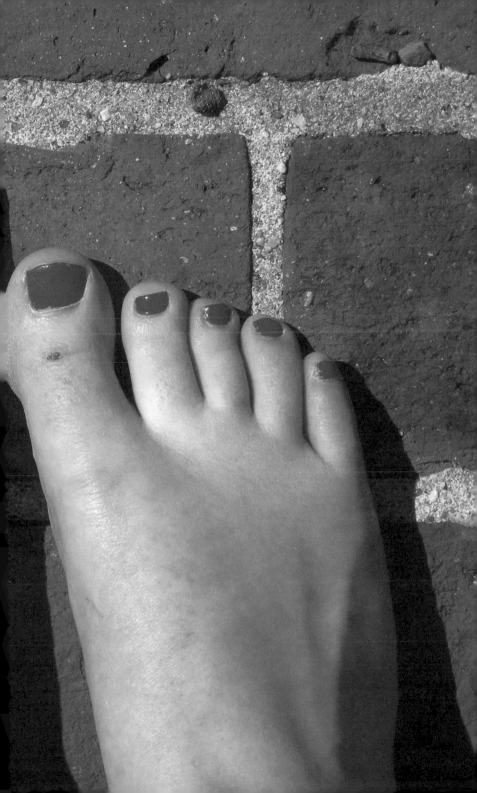

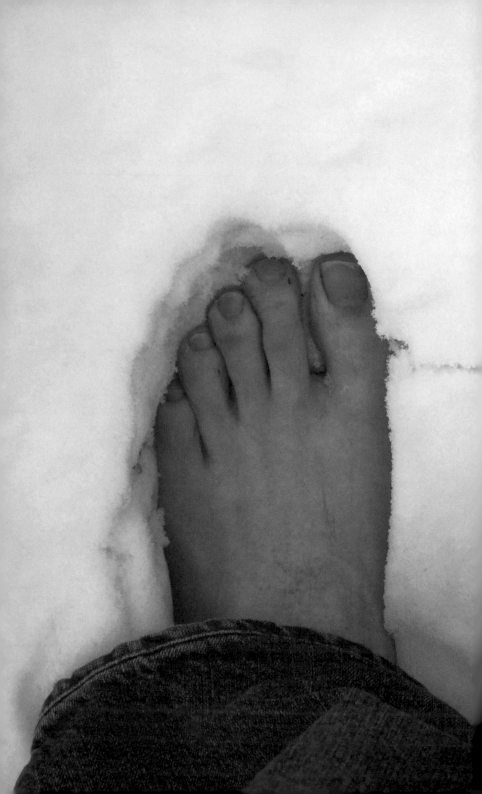

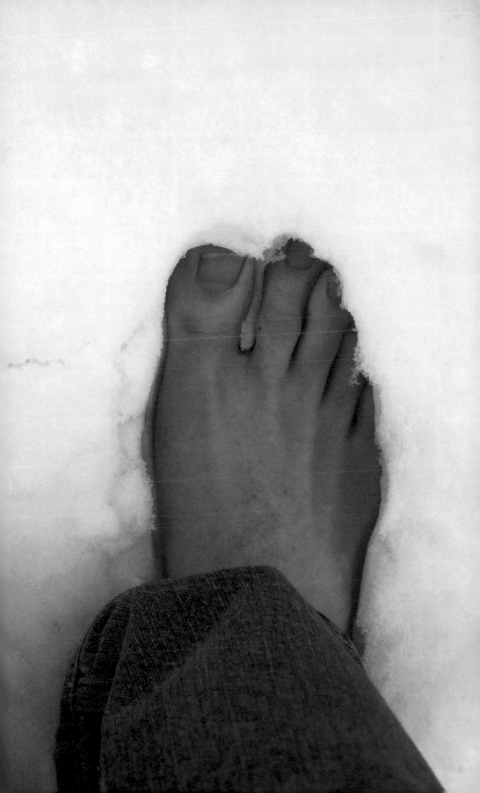

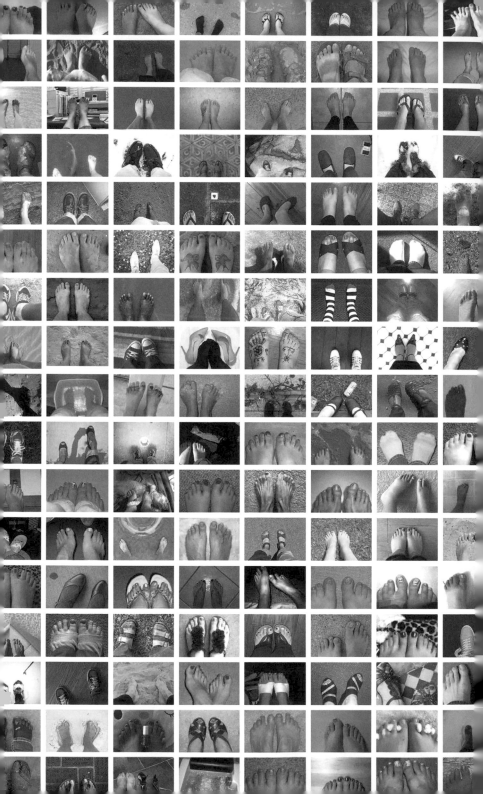

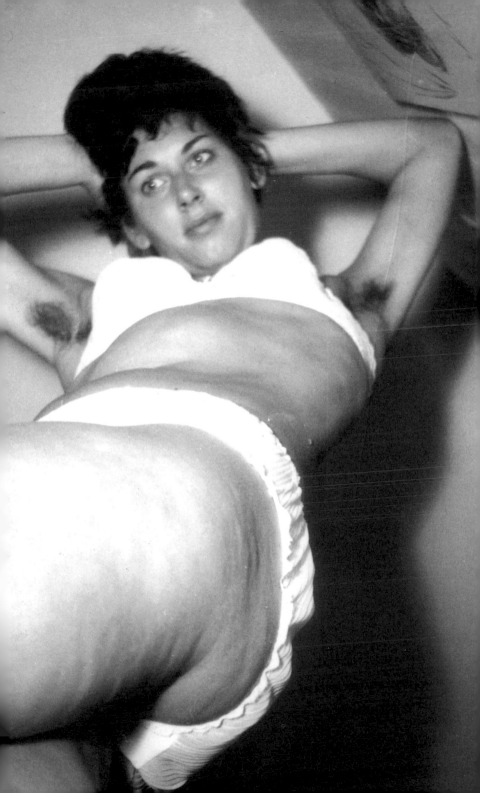

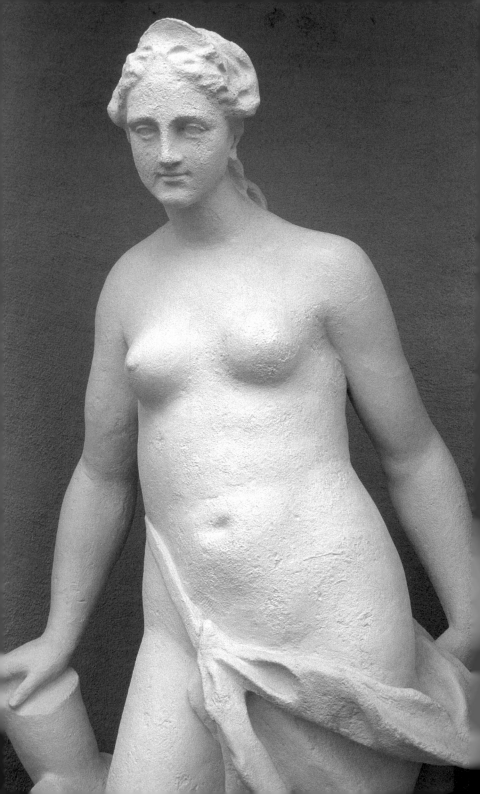

THE

'OFF'

MOMENTS

...

... IN PHOTOGRAPHS ARE OFTEN MORE INTERESTING THAN THE PERFECT ONES.

IN ALMOST EVERY PICTURE
11

in almost every picture #11 (2012) is the story of an obsession spanning decades. Fred (husband and photographer) shows Valerie (wife and model) in a perfect composition and it's not just the framing that's flawless: Valerie is for the most part impeccably dressed, even while up to her neck in the couple's pool. The source of water in the pictures varies as much as the outfits. At times Valerie's almost completely underwater, only her head held above the surface. In other moments, she's on her knees in front of a lawn sprinkler or standing soaked indoors, sipping champagne. Showers and baths are a favorite source of this unusual erotic play, but even Valerie in the rain serves as inspiration for another shot in the series.

Fred explains the rules: "A good part of the wet clothes adventure concept for us is the mental turn-on of taking a nice outfit into the water. Often, the more classy the outfit, the better! We love the watch, earrings, pendants, and jewelry in general going in. Sensuous, erotic stuff. And wearing a bathing suit under your clothes is cheating."

Pages 376–77, 382–83: *in almost every picture #11*, Festival Images Vevey, Switzerland, 2014.

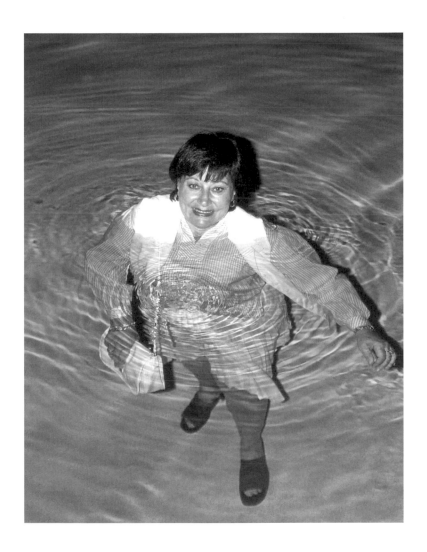

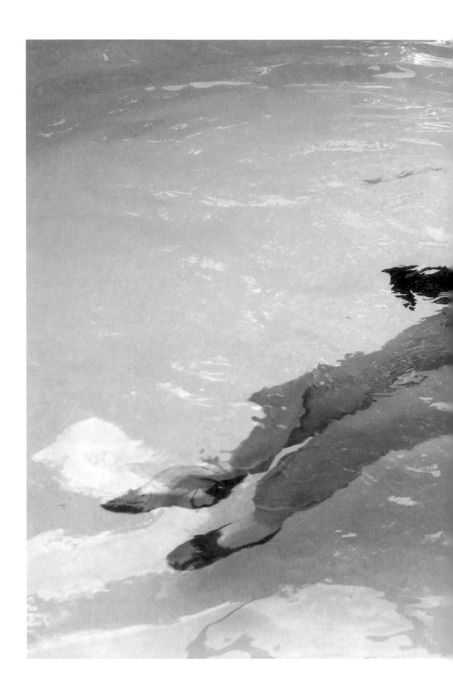

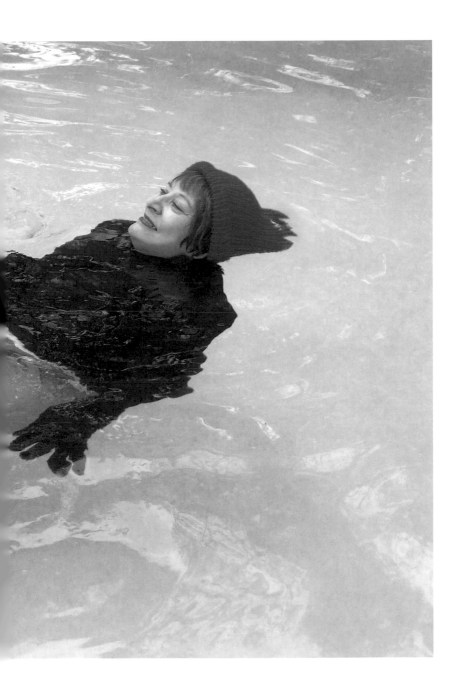

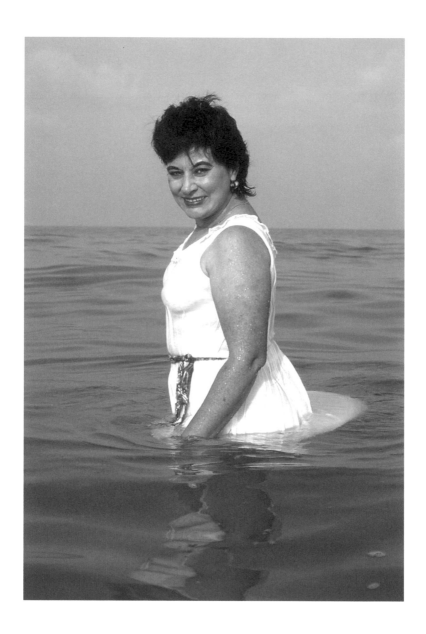

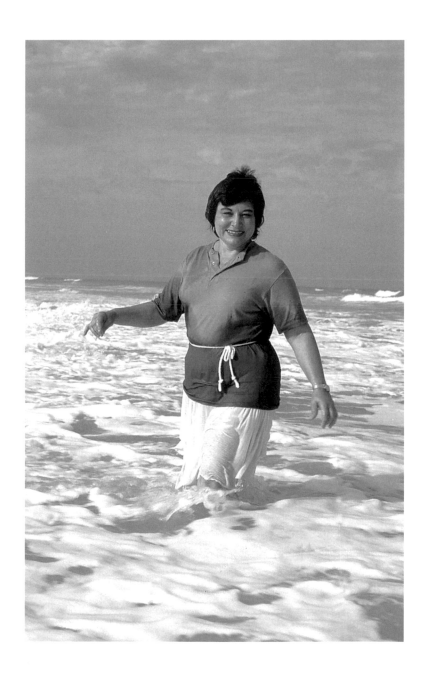

375

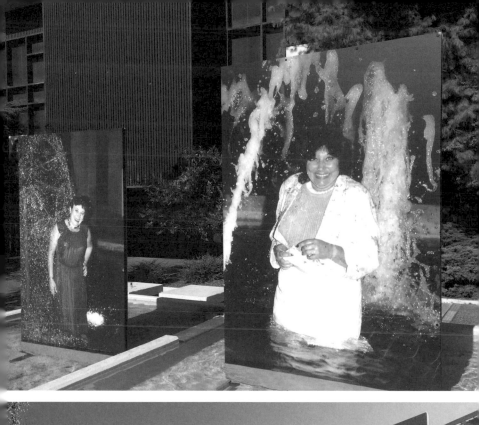
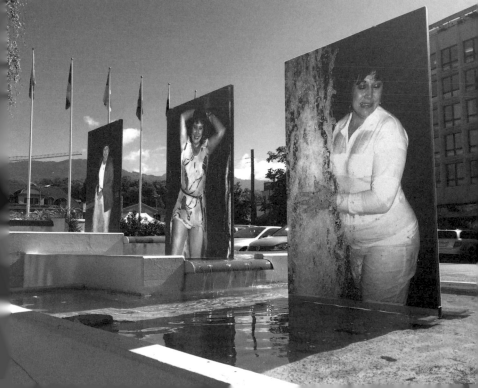

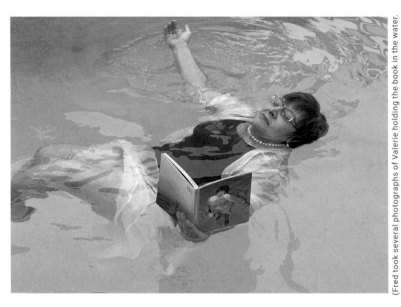

(Fred took several photographs of Valerie holding the book in the water. They both enjoyed the "tantalizing intrigue of it.")

COUPLES

In *Couples* (2008), we see a seemingly widespread but fascinating habit: married couples photographing each other in exactly the same location, and sometimes even in exactly the same pose. A series that gives an insight into how lovers view one another, and how two separate images (and two separate people) can nevertheless make one coherent whole.

394

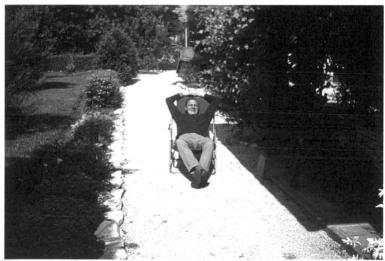

ALBUM
BEAUTY

Album Beauty (2012) is an ode to the vanishing era of the photo album. Once they were a repository for family history, often representing a manufactured family as edited for display. They speak of birth, death, beauty, sexuality, pride, happiness, youth, competition, exploration, complicity, and friendship. The exhibition had albums on display in original form and as larger-than-life reproductions, giving the viewer the feeling of walking through numerous personal stories from around the world.

Pages 404–5, 408, 409: *Album Beauty*, FOAM, Amsterdam, 2012.

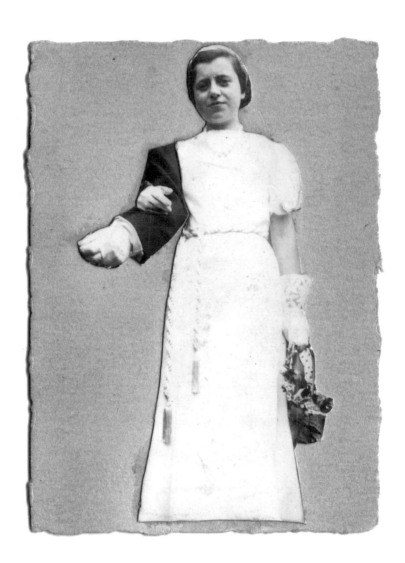

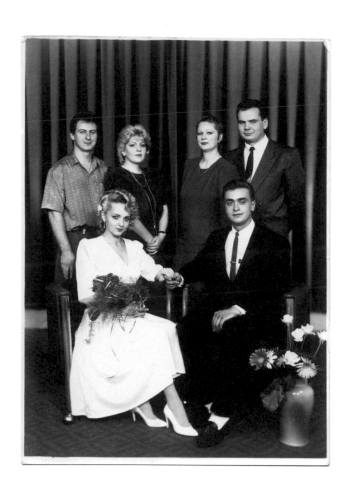

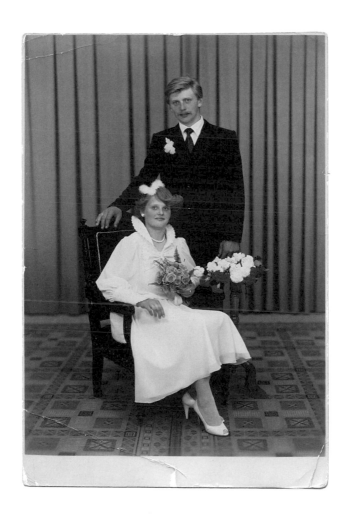

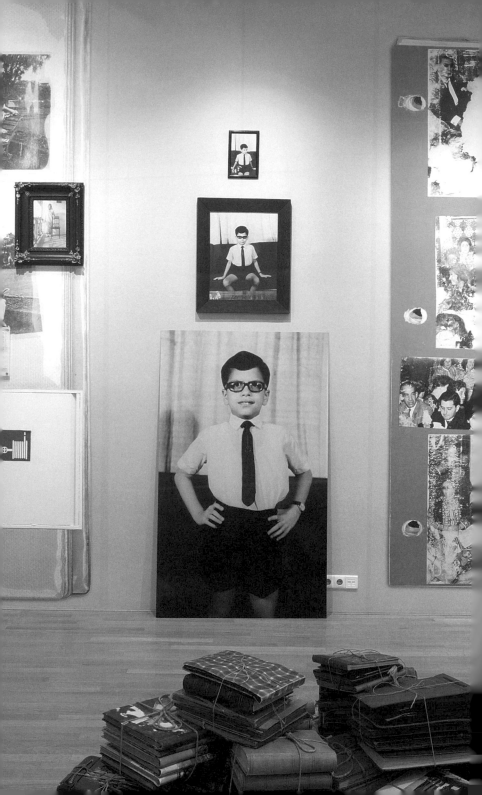

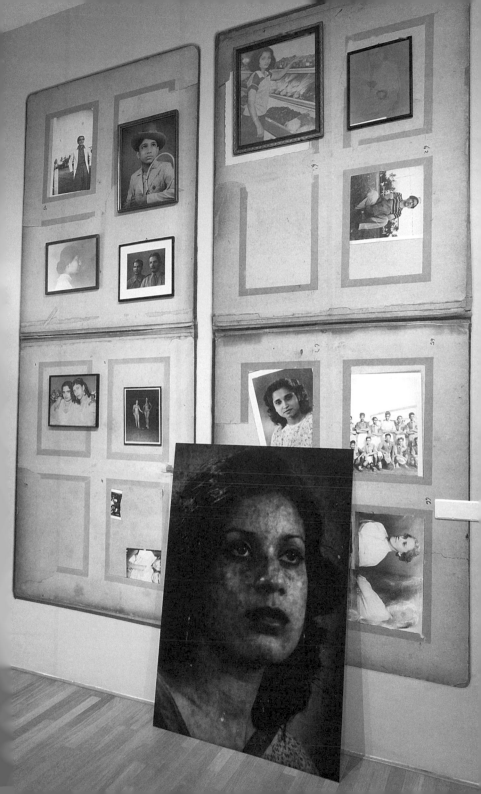

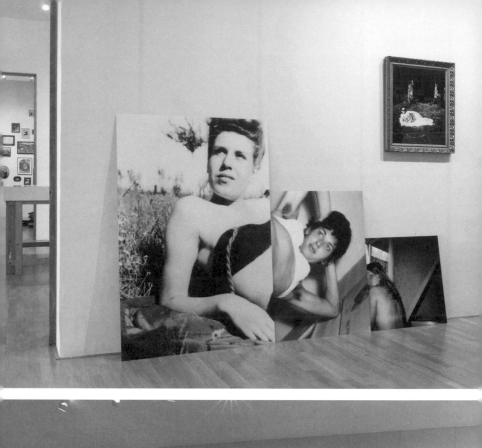

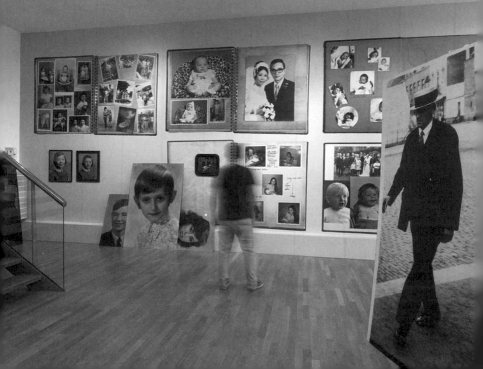

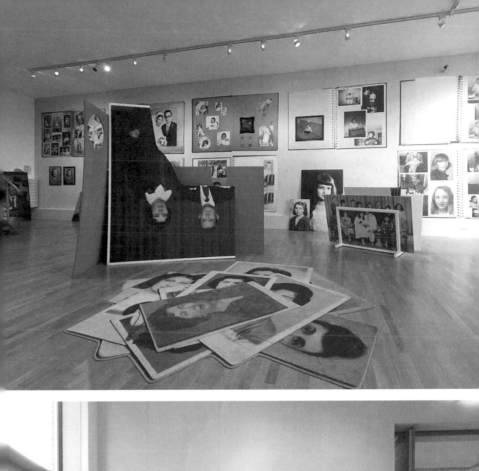

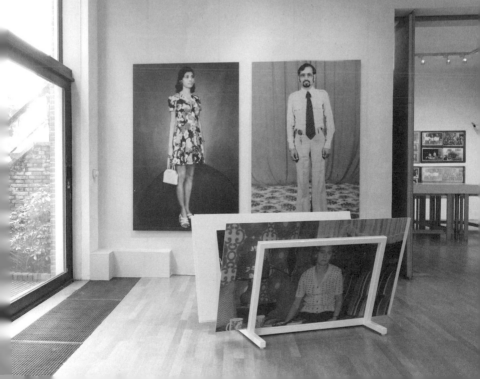

(A girl who found old photo albums on the street in Amsterdam wanted to give them to Erik.
As she packed them for transport, an envelope with 3500 euros fell out. In the end both of them were extremely happy.)

IN ALMOST EVERY PICTURE

12

The twelfth edition of *in almost every picture* (2013) tells the story of a Moroccan wedding filmmaker with a knack for self-promotion. Larbi Laaraichi lives in Fez, where he's been capturing the happiest days of people's lives since the early nineties. While videoing their big days, he also ensures that he gets a shot of himself in action. These images plaster the walls of his shop. We see changes in Laaraichi's fashion taste, from the extremes of turn-of-the-century stripy shirts to more demure contemporary clothing. And we see his career path through his equipment: from proudly wielding an old-school video camera to (a decade later) standing atop a stepladder with a slick, space-age camera. Laaraichi sprawls on a golden throne with friends, or poses in an ornate fountain. He's managed that rare trick: enjoying his means of earning money.

(The Moroccan wedding filmmaker Larbi Laaraichi has, apart from his film camera, a passion for another instrument. Both passions lean on Larbi's shoulder.)

(On average Erik receives fifteen packages by mail per week. Once he received his own weight in spaghetti, which he won at a bingo contest.)

BOMBAY
BEAUTIES

This collection (2009) comprises a selection of pieces discovered by Kessels in Mumbai. It depicts a rich mix of ordinary subjects, from hairdressers' models to family shots to wedding images. Mixed in with this cross section of typical folk are rare shots of Bollywood actors and stars. Taken together, these show the rich diversity of the city, hinting at its untold stories and lives.

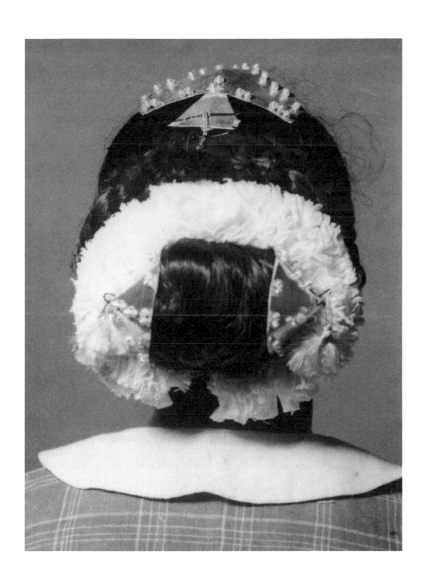

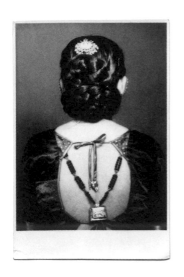

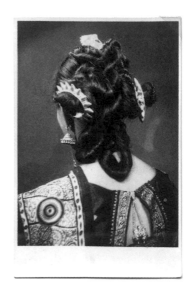

UNSEEN

...

. . . PATTERNS IN PHOTO ALBUMS, THAT'S THE REAL TREASURE HUNT. IT'S LIKE VISUAL ARCHAEOLOGY.

DEDICATION
HANS AARSMAN

Everything is subject.

Subject is everything.

Celebrate life, don't be scared and keep looking.

Everything is subject.

Really, everything.

That's the message of Erik's work.

His father is called Piet. My father was called Henk. Our
fathers didn't know each other. I do know Piet. Erik doesn't
know my father. Henk died twenty-five years ago, a long
time ago already. Henk had a butchery, but what he really
wanted was a garage. So he got the required papers, now all
he had to do was start. He didn't dare to. A family of four
children, it was a big gamble. Maybe it was for the best, Henk
was no technician. Became a butcher because his father was
a butcher, in a time of crisis, there was not much choice.

Henk's unfulfilled car dream hopped over to me. I know
everything about cars. When I'm out cycling, all I need to
see is the tiny edge of a fender next to me to know what type
of car is overhauling me. I also know everything about
the technique. But I do not own a car. I have a bike. I don't
need a car, I keep telling myself. Who needs a car? I mean,
really needs it?

In the Kessels family the love of cars took a different
turn. Erik owns three. He has an everyday car, a Chrysler
Voyager, if I'm correct. Although it could easily be a different
one by now. A Peugeot 304 S convertible. And a Citroën
DS. His father owns four cars, all four of them are Fiat

"Topolinos." That means "Mickey Mouse" in Italian. The legendary itsy-bitsy Fiat that entered the market in between the wars. Half a million of them were produced.

I almost drove in one of Piet's Topolinos once. That was during the fiftieth wedding anniversary of Erik's parents. Even though Piet suffered a stroke the year before, the party went on. We celebrate life and we're not scared. Piet sat on a chair, looked around, wasn't able to speak. Erik had parked the Topolinos in the driveway of the restaurant we were at. In between the soup and the main course we went outside to look at the cars. What a great restorer that man is. Everything is subject, but never forget about dedication. "Take it for a spin?" says Erik. That you don't have to ask me twice. Very odd, the first Topolino didn't start. Neither did the second. We burst out laughing. "They can feel that Piet isn't at the wheel."

There is also a fifth Topolino. Piet was still working on it when he suffered the stroke. He had photographed all the stages of the restoration. Erik turned this into a magisterial exhibition. And a book, *Unfinished Father*. His best work, together with his father. The pictures are printed on stickers, you need to apply them yourself. I did that. I'm left with some empty spaces.

MY
FAMILY

Whenever one of Kessels's kids sustained a bump while out playing, he'd take a snap. Soon, he had a collection of black eyes and bloody noses, and a new way of bonding with his children. The photos were a way of being proud of their scrapes. Naturally, all three of his kids are reasonable enough not to go out and deliberately injure themselves in order to get in a photo. Not only would this be unsupportable as a parent, it would go against what the project is about: *a series that always concerns real experiences, creating a more realistic version of the shiny, fake family album.*

Eventually, Kessels used one of these images as the main promotional shot for a documentary film about his work, *Kessels' Eye.* It was a way to show pride in his offspring. Others found the image shocking. Without knowing the full story, it was assumed that he was showing abused children. As an experiment, he also approached publishers with his series. The reactions were similar: they were terrified.

(About one hundred readers unsubscribed from their magazine after Erik's daughter appeared with a bloody nose on the cover.)

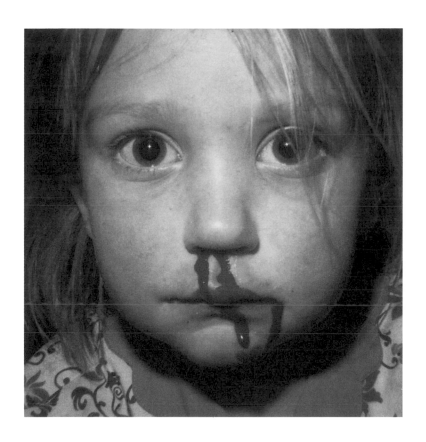

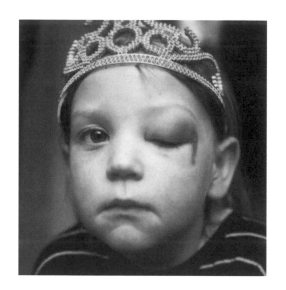

It seems that we've created a series of rules by which children should be photographed. Kids must be always laughing, always happy, or always doing charming things. Kessels believes these shocked responses have to do with the fact that we've been taught to interpret pictures in one very particular way. A setting sun is always romantic and a kid with a bloody nose has of course been the victim of some adult predator.

So we opt for self-censorship, hoping that excluding "bad" images will somehow cause the memories themselves to evaporate. According to Kessels, this is unfortunate; reflecting on an unpleasant occurrence can give you insight and broaden your perspective. Images should reflect life in all its complexity. Sure, that sounds like a mighty demand, and likely impossible, but let's give it a go.

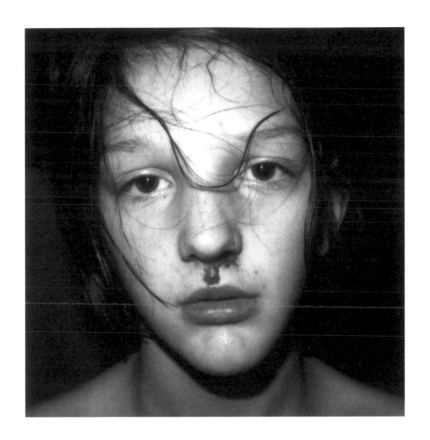

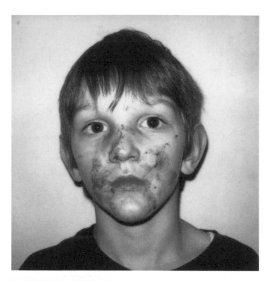

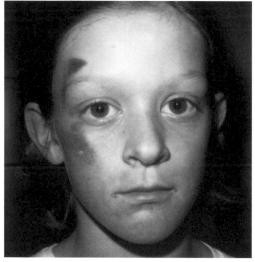

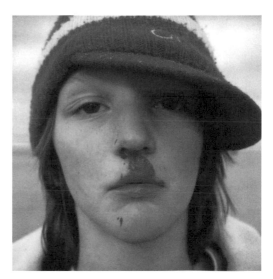
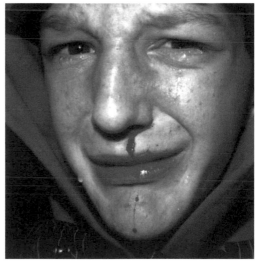

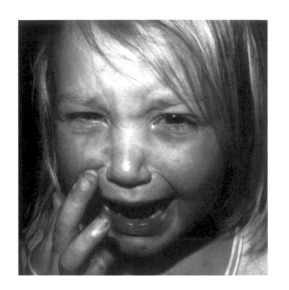

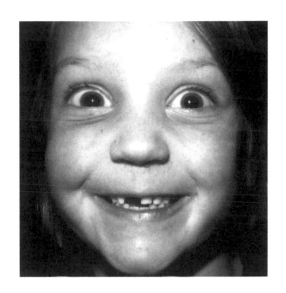

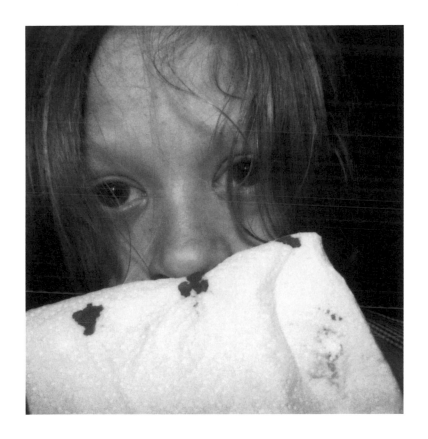

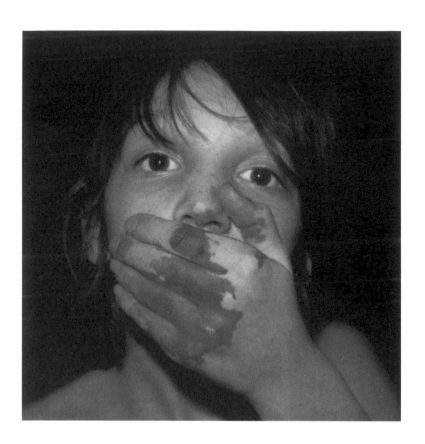

IN ALMOST EVERY PICTURE

13

in almost every picture #13 (2014) is about the most
common mistake in the history of image-making: part
of the photographer's hand appearing in frame. It traces
this eternal error through the ages, from black-and-
white photos to the digital era. Over the course of this
book, the images become increasingly abstract, moving
from a portrait with the occasional blurred digit visible,
all the way to Rothko-like compositions in which
blotches of light and color eradicate all recognizable
forms. Once or twice, we're left wondering whether
malicious intent lies behind the encroaching finger.
For instance, there's a family portrait from the middle
of the last century in which the heads of two women
are neatly covered up.

At the opposite end of the spectrum, there are
examples that strike us as oddly funny: a shot of a
couple on a mountain is so monumentally messed
up that it manages to both whack their heads off and
include a smear of thumb.

A compendium, then, of accidental fingers, mys-
terious thumbs, and vast palms obliterating loved ones
and landscapes alike . . . for purposes that we can only
speculate at, and frustrations we can only imagine.

Pages 476–77: *in almost every picture #13*, in *FOUND*,
The New Art Gallery Walsall, UK, 2015.

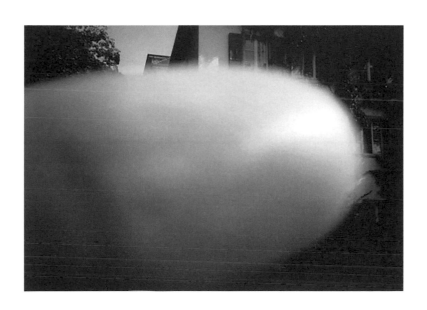

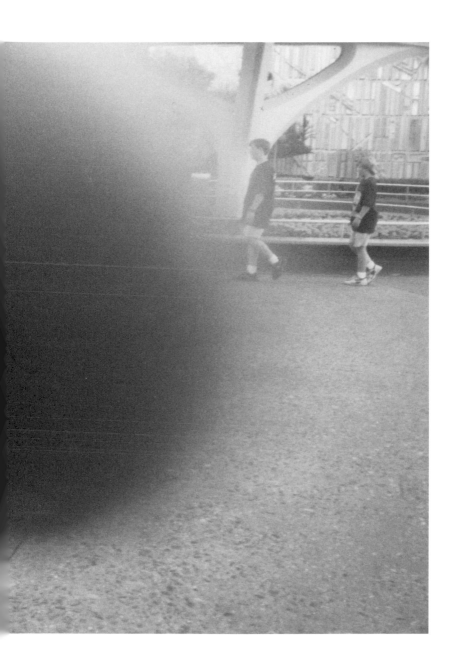

09/10/2012 08:57

475

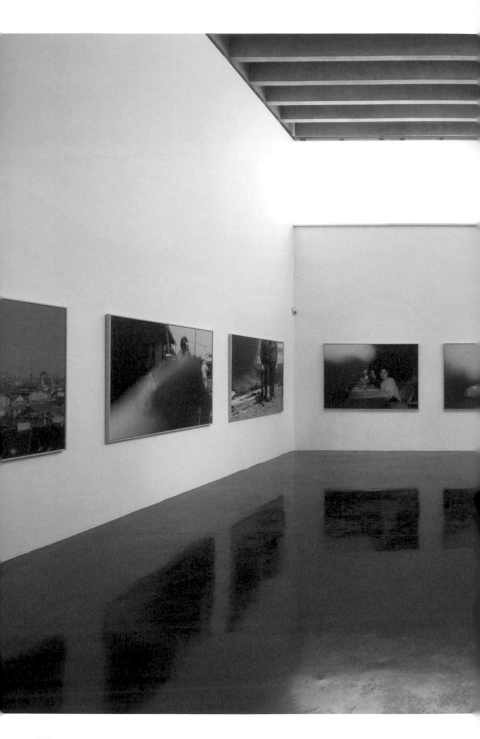

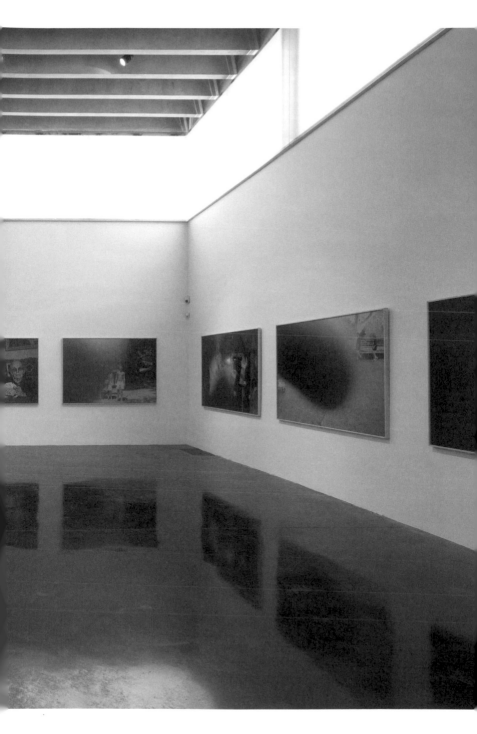

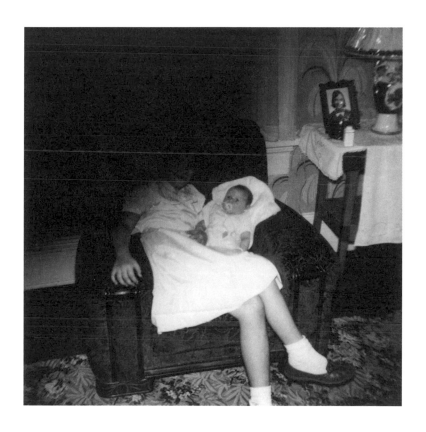

SMALL
CHANGE

Small Change (2016) is a documentation of and a tribute to a little-known Internet phenomenon. Online auction sites often show photographs where details or sections of the photograph have been covered due to privacy and/or censorship issues. This means that sellers are forced to come up with smart and practical solutions so that the photograph conforms to the site's guidelines, but still shows enough of the image to interest prospective buyers.

This often results in accidental and sometimes hilariously interesting new images. Kessels purchased the book *Ein Volk ehrt seinen Führer* (A nation honors its leader) at an online auction. It caught his attention because the seller had censored the photos using carefully placed coins. The coins added a new dimension to these controversial images, which inspired him to create a facsimile—a reproduction of the original but completely censored, from front to back. It's a political cover-up that might actually make you smile.

485

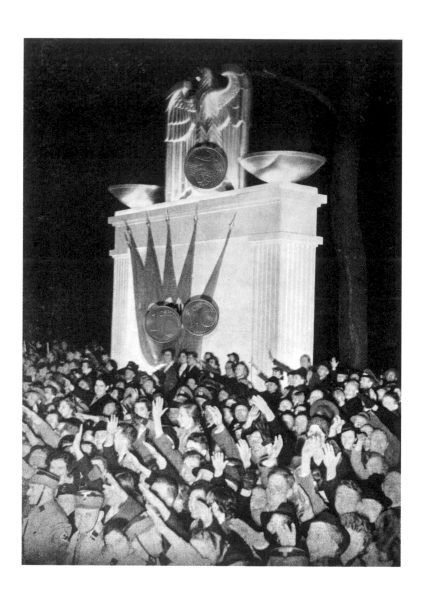

IN ALMOST EVERY PICTURE
14

in almost every picture #14 (2015) invites us to partake in a seminude detective story: a collection of sunbathers with their heads (and often large chunks of their bodies) punched out of their Polaroid frames. Confronted with these images, it's natural that we should fill all that white space with our own theories. Maybe a vengeful lover savaging his or her holiday snaps? Or are these found images the remains of someone's weird abandoned art project? It does what every good detective yarn should do: leaves us guessing until the end. Because it's in the book's closing notes that all is revealed. In actuality, these images were made by a photographer looking to make some quick cash. These shots were intended to have their center removed . . . and applied to a personalized badge, which was then sold to the subject. In the end, the truth is more innocent than our more imaginative speculations.

AYLA BAŞAR

THE

IN
TER
NET

...

. . .
SURPRISES US,
IT SHOWCASES
THE THINGS THAT
OTHERWISE STAYED IN
SHOEBOXES AT
THE BOTTOM OF
A CLOSET.

USEFUL PHOTOGRAPHY

Useful Photography (2001–ongoing) is the generic name of the millions of diverse photos that are used daily for a purpose: photography with a clear function; the makers remain anonymous. The easiest way of judging the true value of a photograph is to take it out of its context. Cut a photo out of a newspaper, put it in a frame, and hang it on the wall. The vast majority will fail the test. But cut out a photograph from a wholesale butcher's brochure, one of those packaging shots of an aluminium tray full to the edges with pink chicken breasts, hang it over your bed, and a year later you still won't be bored when looking at it.

Think of photographs from sales catalogues, instruction manuals, packaging, advertising brochures, and textbooks. Photos published mostly without the makers' names mentioned. It is precisely these photographs, which we are confronted with daily, without even being aware of it, that can sometimes hold our interest for an astonishingly long time.

Page 518 top: *Useful Photography #001* installation, Amsterdam, 2011. / Page 518 bottom: *Useful Photography #001*, Les Rencontres de la Photographie, Arles, France, 2003.

USEFUL PHOTOGRAPHY #001

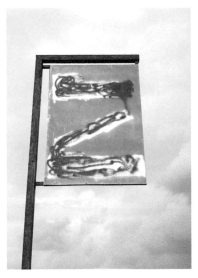
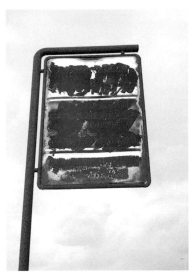

517

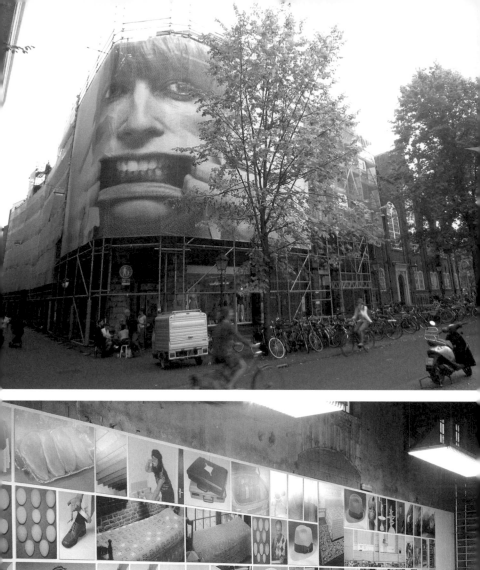

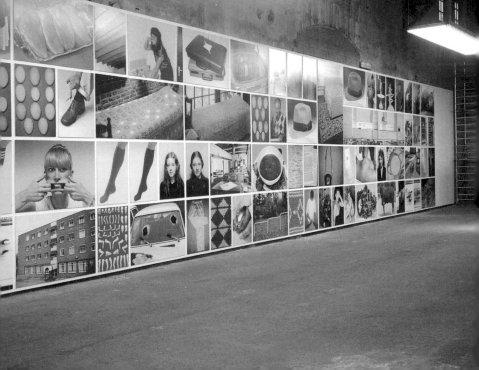

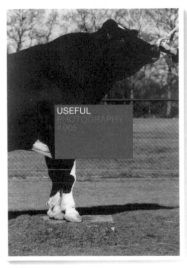

USEFUL PHOTOGRAPHY #006

USEFUL PHOTOGRAPHY #007

USEFUL PHOTOGRAPHY #008

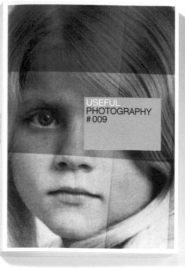

USEFUL PHOTOGRAPHY #009

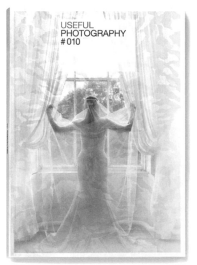

USEFUL
PHOTOGRAPHY
#010

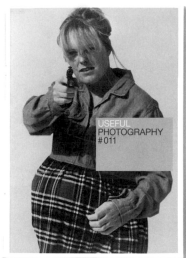

USEFUL
PHOTOGRAPHY
#011

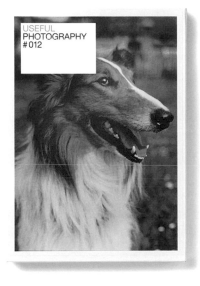

USEFUL
PHOTOGRAPHY
#012

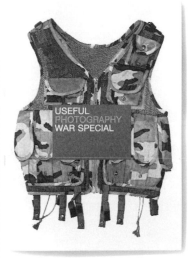

USEFUL
PHOTOGRAPHY
WAR SPECIAL

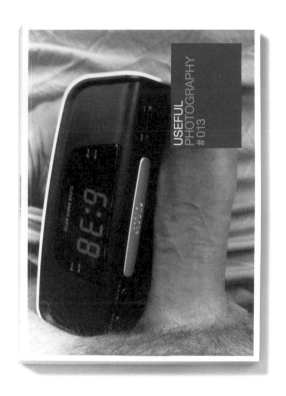

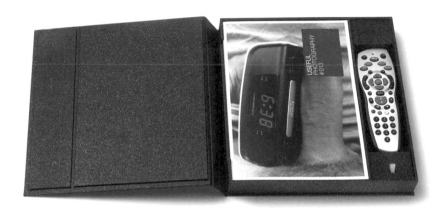

USEFUL
PHOTO-
GRAPHY
#001-005

BOOKS...

Although the topics range from a rabbit with a special talent, to beauty rituals, to police uniforms, to the work of his own father—all Erik Kessels's books share the same common principle: existing photographs are repurposed and taken out of their original context. Via selection and editing they get a new meaning and help you see things you otherwise would probably have overlooked. The images can come from everywhere but are mostly found in family albums, archives, or on the Internet. As of 2016, Kessels has published over sixty titles.

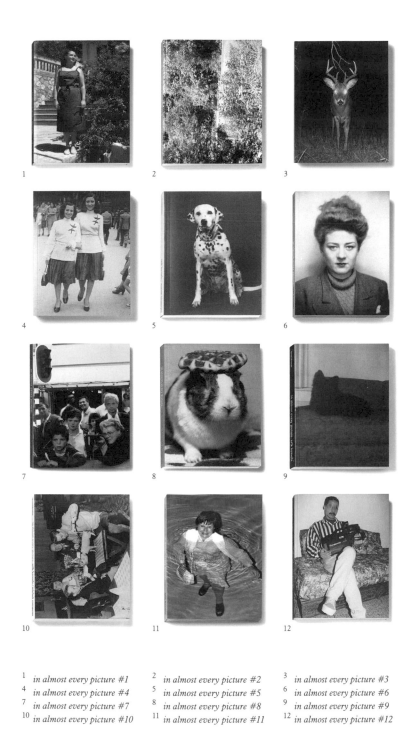

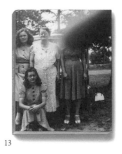

13

14

15

16

17

18

19

20

21

22

23

24

25

26

27

28

29

30

31

32

 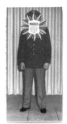

33

34

35

36

 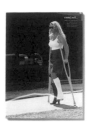

37 38 39

 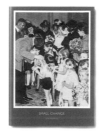

40 41 42

43 44 45

 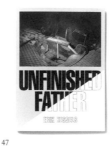

46 47 48

(Although an above-average portion of Erik's books is about dogs, he doesn't really like them. And that feeling is usually mutual.)

37 *Photo Cubes* 38 *Photostory* 39 *Remind*
40 *Shining in Absence* 41 *Small Change* 42 *Strangers in My Photoalbum*
43 *Tables to Meet* 44 *Terribly Awesome Photo Books* 45 *Tree Paintings*
46 *Use Me Abuse Me* 47 *Unfinished Father* 48 *Wonder*

... AND MORE

PISSING FOOTBALL PLAYER

Those who are acquainted with amateur sports have all seen it: a player who can't hold it in any longer and dives into the bushes beside the field to take a quick piss. The idea behind the work is to immortalize this common and recognizable moment that most of us would rather turn away from. We see a soccer player in his ASV Arsenal uniform. He is cut out of stone at the edge of the grounds, his back to the field, pissing for eternity.

Pissing Football Player, ASV Arsenal—Voetbalclub Amsterdam, 2013.

MUSEUM MINUTES

It's well-known that museum visitors don't spend much time studying paintings. In fact, their attention lasts as little as nine seconds per work. What's less well-known is that we give a lot more time to another activity: watching TV while using a treadmill. An average of twenty whole minutes. *Museum Minutes* (2012–13) seeks to combine these two observations. By erecting a line of treadmills in front of famous paintings, the installation encourages people to spend a few more moments with works of art. A timer lets you know how long you've devoted to each painting, adding an extra layer of motivation. *Museum Minutes* was created with the intention of stimulating debate about the degree to which we're willing to prioritize culture.

Museum Minutes, Kunsthal Rotterdam, the Netherlands, 2012–13.

ALL YOURS

The sheer volume of readily available images and the mind-boggling speed at which they appear has led to a growing amount of artists choosing to reappropriate existing imagery rather than trying to create a completely new image. *All Yours* (2015) is an installation containing an overview of a large amount of images from Erik Kessels's collected vernacular photographs. The installation is made of sixteen postcard racks, filled with 1,152 postcards. The public can look at the work as an exhibition, but can also interact with it by taking and using their favorite images as postcards. In this way the reappropriated images will again get another life.

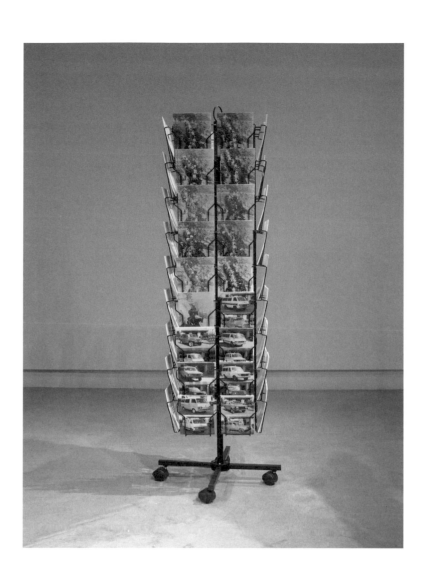

All Yours, Occurence: Espace d'art et d'essai contemporains,
Le Mois de la Photo, Montreal, 2015.

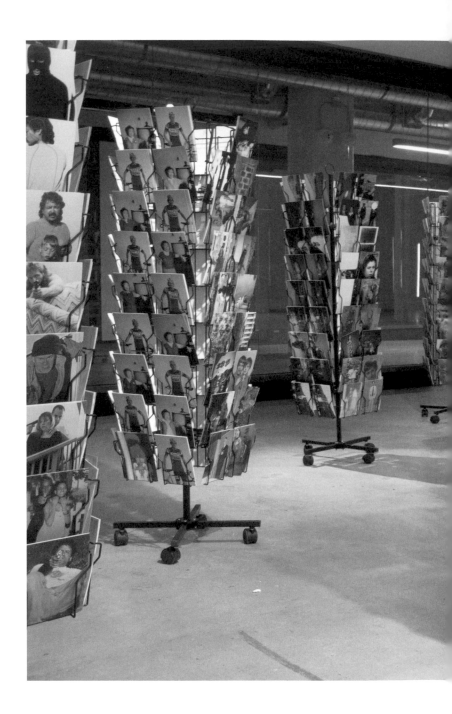

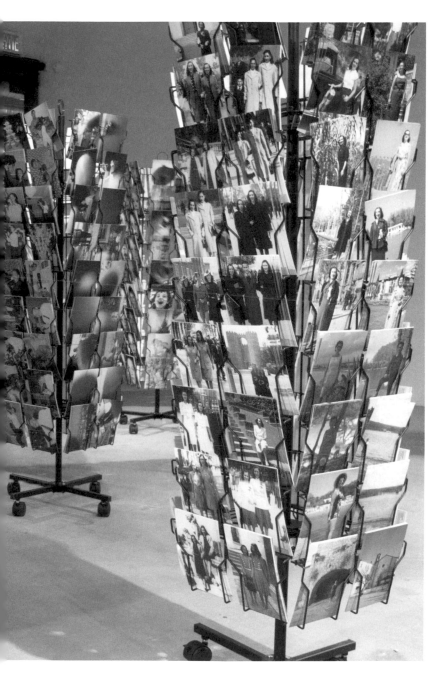

All Yours, Occurence: Espace d'art et d'essai contemporains,
Le Mois de la Photo, Montreal, 2015.

MEMORY PALACE

This installation has the form of a building constructed from compressed cubes of rubbish (like those produced by a garbage compactor). Being entirely made out of recycled materials, it literally represents a memory palace. The real-life, cathedral-like structure is full of snippets of things that once were something, but not anymore. Visitors are able to walk through and around it, interacting with the mass of leaflets, tins, bags, magazines, and other compacted information that forms its structure. What conclusions would a single word or piece of a label lead us to about the people who created it? Walking through the interior of this building, we're walking through a representation of the human mind, a place where meanings and interpretations are amassed for our recollection and where we are overwhelmed by colors, shapes, and images in a constant onslaught of designed materials we face on a daily basis.

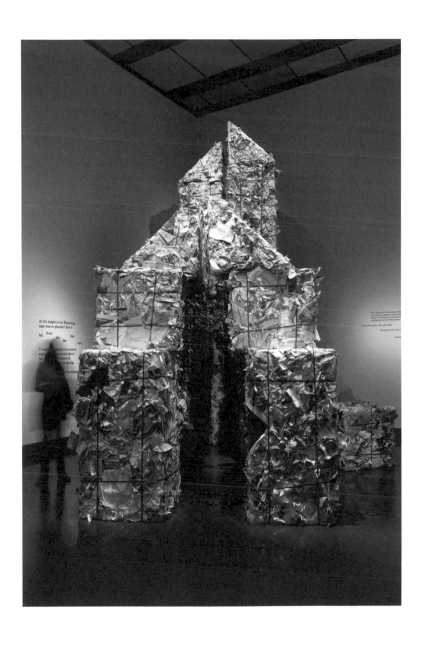

Memory Palace, in *Sky Arts Ignition: Memory Palace*,
Victoria and Albert Museum, London, 2013.

TREEBENCH

In a public park you often see trees and a park bench, but never a combination of both. With this *TreeBench*, visitors of the park will be surprised by the unusual merging of the two. The tree is actually growing straight through the bench. The purpose of this work is to give people a new exciting perspective of a place that is totally common. An extra advantage is that the person who takes a place on the bench has the company of a tree next to them: a relationship that can only grow in time.

TreeBench, Boxtel, the Netherlands, 2014.

EINWANDERER (IMMIGRANTS)

Some 16.3 million German citizens have an immigrant background. The number of illegal immigrants trying to get to Germany (since the reunification) is at a record high. Authorities have been struggling to provide accommodation for refugees, and the debate over immigration has grown increasingly polarized.

Einwanderer (2016) is an installation with many faces. The space is completely filled with passport photos of hundreds of German immigrants, creating a human mosaic of hundreds of individual photographs. The installation engages with the viewer on several levels, making reference to Germany's immigrant history in the wake of the Second World War and how this initial influx shaped the changing face of the German population. It also engages with the current issues around cultural diversity and immigration which are (and will undoubtedly continue to remain) sensitive and complicated topics in contemporary Germany's social and cultural discourse. Together with this exhibition Erik Kessels designed a floor mat. This typical home-welcoming item invites viewers and visitors to "greet immigrants home."

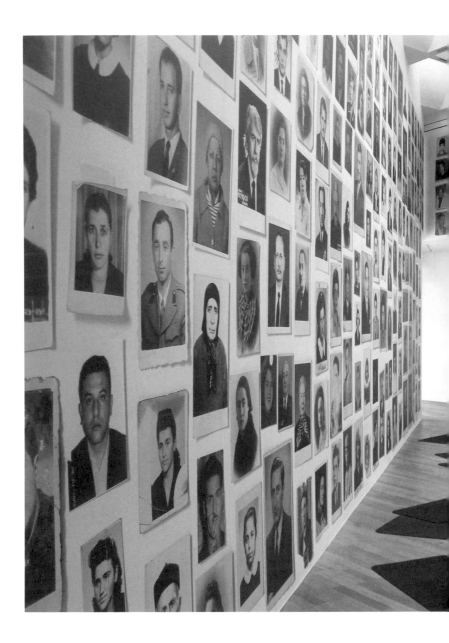

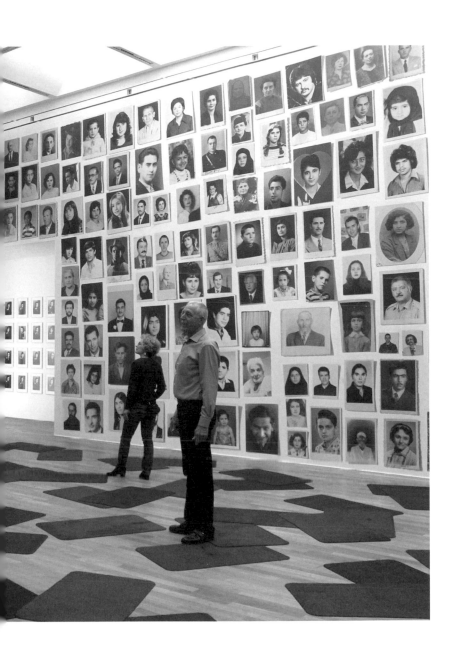

Einwanderer, in *Mit anderen Augen* (With different eyes), Kunstmuseum Bonn, 2016.

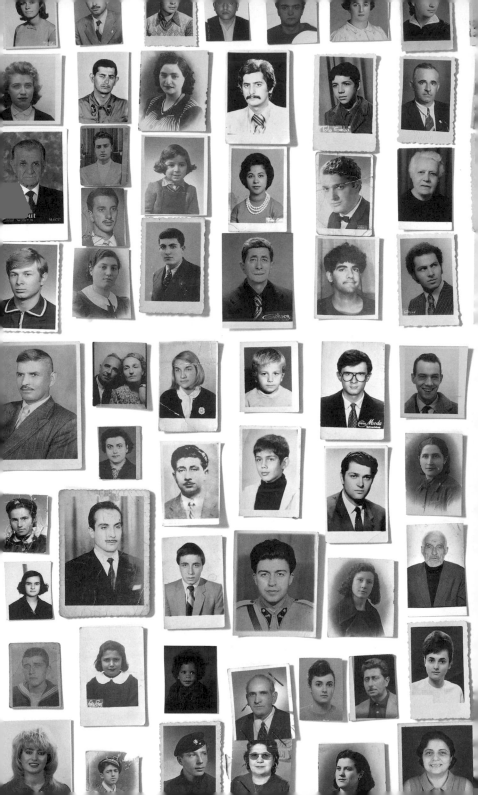

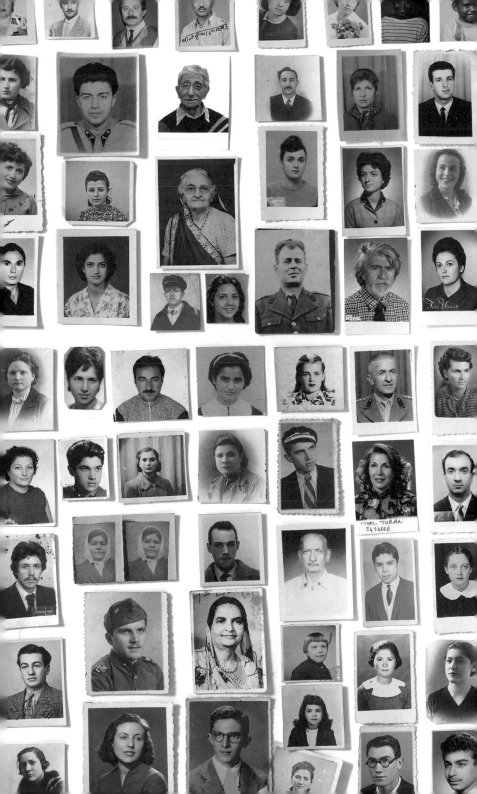

SNORING

It's the sound that keeps the earplug industry afloat. The sound that drives sleepless, bleary-eyed partners to beat their sleeping other half with a pillow and into a separate bed. Why would anyone want to immortalize on vinyl the sound of air rattling noisily through cramped nasal passages? Well, why not? Because *Snoring* (2016) on vinyl actually has more practical uses than you might think. Like a lot of popular music, snoring is one of those noises that grows on you. At first it drives you past crazy until you're verging on homicidal. And then, you get used to it; eventually it becomes familiar, comforting even.

FABULOUS FAILURES

Fabulous Failures (2016) is about the art of embracing serendipity and mistakes.

Nowadays most art, design, and photography portray perfection. As a result, contemporary popular culture is drowning under a tidal wave of superficiality and over-perfection. Posed, polished, and controlled. As if it were a reflection of our endless search for clarity and calmness and an antidote for the chaos in our lives.

An overabundance of skills and techno-logical crutches eliminate the possibility of beautiful mistakes, of stunning failures and any result other than exactly what the maker set out to achieve. Luckily, failing is something artists and photographers more and more take on as a subject for their work. This exhibition shows a large over-view of the best fabulous failures found in contemporary art, design, and photography, made by a group of artists who like to fight perfection and embrace serendipity.

Fabulous Failures, Les Rencontres de la Photographie, Arles, France, 2016.

Fabulous Failures, Les Rencontres de la Photographie, Arles, France, 2016.

Fabulous Failures, Les Rencontres de la Photographie, Arles, France, 2016.

I BELIEVE THAT ...

...PROFESSIONALS CAN LEARN A LOT FROM AMATEURS AND VICE VERSA

APPENDIX

Erik Kessels (born in Roermond, the Netherlands, 1966) is a Dutch artist, designer, and curator with a great interest in photography. Since 1996, Kessels has been creative director of the communications agency KesselsKramer in Amsterdam, where he works for national and international clients such as Nike, Diesel, J&B Whisky, Oxfam, Ben, Vitra, citizenM, and Hans Brinker Budget Hotel. As an artist and photography curator, Kessels has published over sixty books of reappropriated images, including *Missing Links* (1998), *The Instant Men* (1999), *in almost every picture* (2002–16), and *Wonder* (2006). Since 2001, he has been an editor of the alternative photography magazine *Useful Photography*. For the DVD art project *Loud & Clear*, Kessels worked with artists such as Marlene Dumas and Candice Breitz. His bestselling book *Failed It!* (2016) is an inspirational guide for creatives, students, and young professionals on the art of making mistakes. He writes regular editorials for numerous international magazines, and has lectured at the D&AD President's Lecture and at several international design conferences, ranging from Singapore and Goa, India, to New York, Toronto, and Bangkok. He has taught at the Gerrit Rietveld Academie, Amsterdam; ECAL, Lausanne, Switzerland; and Amsterdam Academy of Architecture, where he curated a celebration of amateurism. Kessels has made and curated exhibitions such as *Loving Your Pictures*, *Use Me Abuse Me*, *24hrs of Photos*, *Album Beauty*, and *Unfinished Father*. He also cocurated the exhibition *From Here On* with Martin Parr, Joachim Schmid, Clément Chéroux, and Joan Fontcuberta. In 2010 Kessels was awarded the Amsterdam Prize of the Arts, and in 2016 he was nominated for the Deutsche Börse Photography Foundation Prize for his project *Unfinished Father*.

SELECTED SOLO EXHIBITIONS

Album Beauty, Shiogama Sugimura Jun Museum of Art, Shiogama Photo Festival, Japan, March 5–21, 2016

All Yours, Occurence: Espace d'art et d'essai contemporains, Le Mois de la Photo, Montreal, September 10– November 7, 2015

Unfinished Father, Fotografia Europea, Reggio Emilia, Italy, May 15– July 26, 2015

Shining in Absence, FOAM, Amsterdam, April 2–12, 2015

24hrs of Photos, Festival Images Vevey, Switzerland, September 13– October 5, 2014

in almost every picture #11, Festival Images Vevey, Switzerland, September 13–October 5, 2014

My Feet, f/stop Festival for Photography, Leipzig, Germany, June 7–15, 2014

Album Beauty, Les Rencontres de la Photographie, Arles, France, July 1–September 22, 2013

24hrs of Photos, Les Rencontres de la Photographie, Arles, France, July 1–September 22, 2013

24hrs of Photos, CONTACT Gallery, CONTACT Photography Festival, Toronto, May 1–June 15, 2013

Album Beauty, FORMAT International Photography Festival, Derby, UK, March 8–April 7, 2013

This Is a Picture, Festival Images Vevey, Switzerland, September 8–30, 2012

Album Beauty, FOAM, Amsterdam, July 29–October 14, 2012

24hrs of Photos, FOAM, Amsterdam, November 11–December 7, 2011

Useful Photography #008, KK Outlet, London, November 1–30, 2008

Useful Photography #002, Fondazione Ado Furlan, Palinsesti Arte Contemporanea, Pordenone, Italy, September 13–November 11, 2008

in almost every picture, Aperture Gallery, New York, March 4–May 17, 2008

Loving Your Pictures, Les Rencontres de la Photographie, Arles, France, July 3–September 16, 2007

Models, Goethe-Institut, Rotterdam, the Netherlands, September 8– November 23, 2006

Loving Your Pictures, Centraal Museum, Utrecht, the Netherlands, April 9– May 28, 2006

Useful Photography #001 and *in almost every picture #1*, Les Rencontres de la Photographie, Arles, France, July 5– September 18, 2005

in almost every picture #2, Nederlands Fotomuseum, Rotterdam, the Netherlands, April 24–June 6, 2004

Useful Photography #001 and *#003*, Les Rencontres de la Photographie, Arles, France, July 5–October 12, 2003

SELECTED GROUP EXHIBITIONS

Einwanderer (Immigrants), in *Mit anderen Augen* (With different eyes), Kunsthalle Nürnberg, Germany, October 14, 2016–January 15, 2017

Unfinished Father, in *Deutsche Börse Photography Foundation Prize 2016*, The Photographers' Gallery, London, April 15–July 3, 2016

Einwanderer (Immigrants), in *Mit anderen Augen* (With different eyes), Kunstmuseum Bonn, February 25– May 8, 2016

My Feet, in *Ego Update: The Future of the Digital Identity*, NRW-Forum Düsseldorf, September 19, 2015– January 17, 2016

FOUND, The New Art Gallery, Walsall, UK, January 30–May 3, 2015

Secondhand, Pier 24, San Francisco, August 4, 2014–May 31, 2015

Mother Nature, in *(Mis)Understanding Photography*, Museum Folkwang, Essen, Germany, June 14–August 17, 2014

Sky Arts Ignition: Memory Palace, Victoria and Albert Museum, London, June 18–October 20, 2013

in almost every picture #7, in *Shoot! Existential Photography*, The Photographers' Gallery, London, October 12, 2012–January 6, 2013

24hrs of Photos, in *Von Sinnen: Wahrnehmung in der zeitgenössischen Kunst* (The human senses and perception in contemporary art), Kunsthalle zu Kiel, Germany, July 14–October 21, 2012

Useful Photography #010, BIP2012: 8th International Biennial of Photography and Visual Arts, Liège, Belgium, March 10–May 6, 2012

My Sister, QPN / Quinzaine Photographique Nantaise, Nantes, France, September 16–October 16, 2011

in almost every picture #7, Saint Nicholas' Church, Gentse Feesten, Ghent, Belgium, July 16–25, 2011

in almost every picture #7, in *Shoot! Fotografie existentiell* (Existential photography), C/O Berlin, February 5–May 1, 2011

My Sister, in *Five Strange Family Albums*, Le Bal, Paris, January 14–April 17, 2011

Graphic Design Worlds, Triennale Design Museum, Milan, January 6–March 27, 2011

in almost every picture #7, in *Shoot! Fotografie existentiell* (Existential photography), Museum für Photographie, Braunschweig, Germany, October 7–November 20, 2010

Useful Photography #004, 8th Gwangju Biennale, South Korea, September 3–November 7, 2010

in almost every picture #7, in *Shoot! Existential Photography*, Les Rencontres de la Photographie, Arles, France, July 3–September 19, 2010

40 Trade Ads, in *EventArchitectuur & KesselsKramer*, Galerie VIVID, Rotterdam, the Netherlands, April 25–June 27, 2010

in almost every picture #1, in *I Was Here*, Centre National de l'Audiovisuel, Dudelange, Luxembourg, March 26–June 13, 2010

Useful Photography #009, in *Matrix*, Philadelphia Photo Arts Center, March 1–May 15, 2010

Oolong & Others, De Zwarte Ruyter, Rotterdam, the Netherlands, December 10, 2009–January 16, 2010

KK Exports: 12 Years of Posters & Other Communication, Guildford Lane Gallery, Melbourne, Australia, June 5–14, 2009

Do box and *Do a plastic bag*, in *Utterubbish! A Collection of UseLess Ideas*, Kaohsiung Design Festival, Taiwan, May 1–31, 2009

Useful Photography Medical, in *Clinic*, Galerie Griesmar & Tamer, Paris, May 28–July 5, 2008

Useful Photography, New York Photo Festival, May 14–18, 2008

Do box, in *Utterubbish: A Collection of UseLess Ideas*, Singapore Design Festival, November 28–December 8, 2007

Useful Photography Medical, in *Clinic*, Open Eye Gallery, Liverpool, UK, June 14–August 1, 2007

Bangkok Beauties, in *Being Beauteous*, White Space Gallery, London, April 20–June 2, 2007

Useful Photography and *in almost every picture*, in *Found, Shared: The Magazine Photowork*, The Photographers' Gallery, London, April 20–June 17, 2007

in almost every picture #8, in *Tous
photographes! / We Are All
Photographers Now!*, Musée de
l'Elysée, Lausanne, Switzerland,
February 8–May 20, 2007
*KK Outlet: 10 Years of KesselsKramer's
Work on Show*, Kunsthal Rotterdam,
the Netherlands, October 21, 2006–
January 14, 2007
Useful Photography #005, in *Dutch Dare:
Contemporary Photography from the
Netherlands*, Australian Centre for
Photography, Sydney, October 19–
December 2, 2006
Useful Photography Medical, in *Clinic*,
Nuit Blanche Paris and Paris Photo,
Paris, October–December 2006
Useful Photography Medical, in *Clinic*,
Septembre de la photographie,
Lyon, France, September 23–
November 18, 2006
Useful Photography, in *Found, Shared:
The Magazine Photowork*, CUBE
Gallery, Manchester, UK, April 14–
June 3, 2006
Loud & Clear & TOO,
Museum Ludwig, Cologne, Germany,
October 27, 2005–April 1, 2006
Useful Photography #005, Foto
Antwerpen 2005, Fotomuseum
Provincie Antwerpen, Antwerp,
Belgium, November 1–26, 2005
in almost every picture #1, in
*Mediterranean: Between Reality and
Utopia*, The Photographers' Gallery,
London, August 12–October 3, 2004
Loud & Clear, Institut Néerlandais,
Paris, February 5–March 7, 2004;
Rooseum, Malmö, Sweden,
April 2–17, 2003;
Reykjavík Art Museum, Iceland,
February 12–27, 2003;
De Balie, Amsterdam, January–
February 2003;
BALTIC Centre for Contemporary
Art, Gateshead, UK, November 23,
2002–January 15, 2003

Strangers in My Photoalbum,
in *Remind*, BredaPhoto 2003,
the Netherlands, September 20–
October 19, 2003
Wonder, FotoFestival Naarden,
the Netherlands, May 29–
June 22, 2003
in almost every picture #1, RAS Gallery,
Barcelona, April 2–May 23, 2002
Useful Photography #001, Fototheek,
DB-S Fotografie, Antwerp, Belgium,
September 9–October 24, 2001
Useful Photography #001, Nederlands
Fotomuseum, Rotterdam, the
Netherlands, February 12–
April 26, 2001
The Instant Men, Art Book, Amsterdam,
November 12–December 1, 1999

SELECTED CURATED EXHIBITIONS

Fabulous Failures, Les Rencontres
de la Photographie, Arles, France,
July 4–September 25, 2016
Small Universe, Centquatre, Paris,
November 13–December 13, 2014
Small Universe, Les Rencontres de la
Photographie, Arles, France,
July 7–September 21, 2014
Museum Minutes, Kunsthal Rotterdam,
the Netherlands, September 29,
2012–January 14, 2013
*Identity Land: Space for a Million
Identities*, curated by Erik Kessels
in collaboration with Droog Lab,
Z33, Hasselt, Belgium,
November 17–December 2, 2012
*Graphic Detour: Crossing Borders
in European Design*, Freiraum
Quartier21 International, Vienna,
September 29–November 25, 2012
*Graphic Detour: Crossing Borders in
European Design*, Direktorenhaus,
Berlin, December 16, 2011–
February 3, 2012

From Here On, curated by Erik Kessels in collaboration with Clément Chéroux, Joan Fontcuberta, Martin Parr, and Joachim Schmid, Les Rencontres de la Photographie, Arles, France, July 4–September 18, 2011

Graphic Detour: Crossing Borders in European Design, Graphic Design Museum, Breda, the Netherlands, June 14–November 27, 2011

Ashley Gilbertson: Bedrooms of the Fallen, Nederlands Uitvaart Museum Tot Zover, Amsterdam, October 20, 2010–January 9, 2011

Paul Fusco: Funeral Train, Nederlands Uitvaart Museum Tot Zover, Amsterdam, June 8–September 26, 2010

Use Me Abuse Me, New York Photo Festival, May 12–16, 2010

Seiichi Furuya: Trace Elements, Nederlands Uitvaart Museum Tot Zover, Amsterdam, January 22–May 16, 2010

Magnum Sees Piemonte, Photography Forum International, Frankfurt, April 9–May 29, 2005

Confrontation, FOAM, Amsterdam, February 12–March 20, 2005

Dutchdelight, FOAM, Amsterdam, December 13, 2001–March 10, 2002

SELECTED PUBLICATIONS

All publications collected, edited, and designed by Erik Kessels unless otherwise noted.

Failed It!: Color, 4¾ x 7 in. (12.0 x 17.8 cm), 168 pages, hardcover. Published by Phaidon, London, 2016.

Image Tsunami: Color, 6½ x 9 in. (16.5 x 22.9 cm), 304 pages, softcover. Published by RM, Barcelona, 2016.

in almost every picture #7 (Updated): Collected and edited by Erik Kessels and Joep Eijkens. Updated edition with 8 new shots. Color and black and white, 6⅛ x 7⅞ in. (15.5 x 20.0 cm), 136 pages, softcover. Published by KesselsKramer, Amsterdam, 2016.

Small Change: Color and black and white, 7½ x 10⅜ in. (19.0 x 26.5 cm), 64 pages, softcover. Published by KesselsKramer, Amsterdam, 2016.

Snoring: Vinyl LP, 12 x 12 in. (30 x 30 cm), numbered, edition of 300. Published by KesselsKramer, Amsterdam, 2016.

Amc² Issue 12: Shining in Absence: Color, 8 x 11 in. (20.3 x 27.9 cm), 120 pages, softcover. Published by Archive of Modern Conflict, London, 2015.

André Behr Pamflet 38: NO MORE TEENAGE LUST: Black and white, 5⅞ x 8¼ in. (15.0 x 21.0 cm), 16 pages, softcover. Published by Boekie Woekie, Amsterdam, 2015.

Beijing Beauties: Black and white, 6¾ x 8⅞ in. (17.0 x 22.5 cm), 24 pages, softcover. Edition of 500. Published by KesselsKramer, Amsterdam, 2015.

in almost every picture #14: Color, 6⅛ x 7⅞ in. (15.5 x 20.0 cm), 178 pages, softcover. Published by KesselsKramer, Amsterdam, 2015.

Unfinished Father: Designed by Angela Lidderdale. Color, 6¾ x 9 in. (17.0 x 23.0 cm), 72 pages, softcover. Edition of 500. Published by RVB Books, Paris, 2015.

Useful Photography #013: Collected and edited by Hans Aarsman, Julian Germain, Erik Kessels, and Frank Schallmaier. Color, 8¼ x 11¾ in. (21.0 x 29.7 cm), 240 pages, softcover. Published by KesselsKramer, Amsterdam, 2015.

in almost every picture #13: Color, 6⅛ x 7⅞ in. (15.5 x 20.0 cm), 178 pages, softcover. Published by KesselsKramer, Amsterdam, 2014.

ME TV: Collected, edited, and designed by Thomas Sauvin and Erik Kessels. Color, 3⅞ x 5½ in. (10.0 x 14.0 cm), 24 pages, hardcover. Edition of 300. Published by KesselsKramer, Amsterdam, 2014.

Mother Nature: Color and black and white, 5⅛ x 8¼ in. (13.0 x 21.0 cm), 140 pages, hardcover. Published by RVB Books, Paris, 2014.

Tables to Meet: By Erik Kessels, Erik Steinbrecher, and Erik van der Weijde. Black and white, 5⅞ x 8¼ in. (14.8 x 21.0 cm), 320 pages, hardcover. Published by 4478zine, Amsterdam, 2014.

Useful Photography #012: Collected and edited by Hans Aarsman, Julian Germain, Erik Kessels, and Hans van der Meer. Color, 8¼ x 11¾ in. (21.0 x 29.7 cm), 104 pages, softcover. Published by KesselsKramer, Amsterdam, 2014.

Berlin Beauties: Black and white, 6¾ x 8⅞ in. (17.0 x 22.5 cm), 24 pages, softcover. Edition of 250. Published by KesselsKramer, Amsterdam, 2013.

in almost every picture #12: Color, 6⅛ x 7⅞ in. (15.5 x 20.0 cm), 178 pages, softcover. Published by KesselsKramer, Amsterdam, 2013.

Incredibly Small Photo Books: Collected and edited by Paul Kooiker and Erik Kessels. Color, 11⅞ x 14½ in. (30.0 x 37.0 cm), 64 pages, softcover. Published by Art Paper Editions, Ghent, Belgium, 2013.

Terribly Awesome Photo Books: Collected and edited by Paul Kooiker and Erik Kessels. Color, 11⅞ x 14½ in. (30.0 x 37.0 cm), 64 pages, softcover. Published by Art Paper Editions, Ghent, Belgium, 2013.

Useful Photography #011: Collected and edited by Hans Aarsman, Claudie de Cleen, Julian Germain, Erik Kessels, and Hans van der Meer. Color, 8¼ x 11¾ in. (21.0 x 29.7 cm), 84 pages, softcover. Published by KesselsKramer, Amsterdam, 2013.

Album Beauty: Color and black and white, 5⅛ x 8¼ in. (13.0 x 21.0 cm), 140 pages, hardcover. Published by RVB Books, Paris, 2012.

Dancing with Numbers: Black and white, 6¾ x 10 in. (17.0 x 25.5 cm), 16 pages, softcover. Published by KesselsKramer, Amsterdam, 2012.

in almost every picture #11: Color, 6⅛ x 7⅞ in. (15.5 x 20.0 cm), 178 pages, softcover. Published by KesselsKramer, Amsterdam, 2012.

Good Luck: Collected and edited by Christine Otten and Erik Kessels. Color, 6⅛ x 8½ in. (15.7 x 21.6 cm), 144 pages, hardcover. Published by Stichting Collectieve Propaganda van het Nederlandse Boek, Amsterdam, 2011.

in almost every picture #10: Collected by Michel Campeau. Edited and designed by Erik Kessels. Black and white, 6⅛ x 7⅞ in. (15.5 x 20.0 cm), 148 pages, softcover. Published by KesselsKramer, Amsterdam, 2011.

Useful Photography #010: Collected and edited by Hans Aarsman, Claudie de Cleen, Julian Germain, Erik Kessels, and Hans van der Meer. Color, 8¼ x 11¾ in. (21.0 x 29.7 cm), 176 pages, softcover. Published by KesselsKramer, Amsterdam, 2011.

Brussels Beauties: Black and white, 6¾ x 8⅞ in. (17.0 x 22.5 cm), 24 pages, softcover. Edition of 500. Published by KesselsKramer, Amsterdam, 2010.

in almost every picture #9: Color and black and white, 6⅛ x 7⅞ in. (15.5 x 20.0 cm), 112 pages, softcover. Published by KesselsKramer, Amsterdam, 2010.

Use Me Abuse Me: Designed by Angela Lidderdale. Color and black and white, 8 x 13⅜ in. (20.5 x 34.0 cm), 32 pages, softcover. Published by KesselsKramer, Amsterdam, 2010.

Bombay Beauties: Black and white, 6¾ x 8⅞ in. (17.0 x 22.5 cm), 32 pages, softcover. Edition of 500. Published by KesselsKramer, Amsterdam, 2009.

in almost every picture #8: Collected and edited by Erik Kessels. Photographs by Hironori Akutagawa. Color, 6⅛ x 7⅞ in. (15.5 x 20.0 cm), 120 pages, softcover. Published by KesselsKramer, Amsterdam, 2009.

Photo Cubes: Designed by Fabienne Feltus. Color, 6¾ x 8⅞ in. (17.0 x 22.5 cm), 48 pages, softcover. Edition of 500. Published by KesselsKramer, Amsterdam, 2009.

Photostory: Color, 5 x 8 in. (13.0 x 20.0 cm), 64 pages, softcover. Published by Blurb, 2009.

Tree Paintings: Photographs by Erik Kessels. Color, 6¾ x 8⅞ in. (17.0 x 22.5 cm), 44 pages, softcover. Edition of 500. Published by KesselsKramer, Amsterdam, 2009.

Useful Photography #009: Collected and edited by Hans Aarsman, Claudie de Cleen, Julian Germain, Erik Kessels, and Hans van der Meer. Color, 8¼ x 11¾ in. (21.0 x 29.7 cm), 170 pages, softcover. Published by KesselsKramer, Amsterdam, 2009.

Amateurism: Color, 6¾ x 9⅜ in. (17.0 x 24.0 cm), 128 pages, softcover. Published by KesselsKramer, Amsterdam, 2008.

Couples: Designed by Fabienne Feltus. Color, 6¾ x 8⅞ in. (17.0 x 22.5 cm), 40 pages, softcover. Edition of 500.

Published by KesselsKramer, Amsterdam, 2008.

in almost every picture #7: Collected and edited by Erik Kessels and Joep Eijkens. Color and black and white, 6⅛ x 7⅞ in. (15.5 x 20.0 cm), 128 pages, softcover. Published by KesselsKramer, Amsterdam, 2008.

On Show: Collected and edited by Erik Kessels. Designed by Browns. Color and black and white, 8 x 9⅝ in. (20.5 x 24.5 cm), 128 pages, hardcover. Published by Howard Smith Paper, London, 2008.

Useful Photography #008: Collected and edited by Hans Aarsman, Claudie de Cleen, Julian Germain, Erik Kessels, and Hans van der Meer. Guest editor: Adriaan van der Ploeg. Color, 8¼ x 11¾ in. (21.0 x 29.7 cm), 80 pages, softcover. Published by KesselsKramer, Amsterdam, 2008.

Bangkok Beauties: Black and white, 6¾ x 8⅞ in. (17.0 x 22.5 cm), 28 pages, softcover. Edition of 250. Published by KesselsKramer, Amsterdam, 2007.

in almost every picture #6: Black and white, 6⅛ x 7⅞ in. (15.5 x 20.0 cm), 136 pages, softcover. Published by KesselsKramer, Amsterdam, 2007.

Strangers in My Photoalbum: Designed by Fabienne Feltus. Color, 6¾ x 8⅞ in. (17.0 x 22.5 cm), 28 pages, softcover. Edition of 250. Published by KesselsKramer, Amsterdam, 2007.

Useful Photography #007: Collected and edited by Hans Aarsman, Claudie de Cleen, Julian Germain, Erik Kessels, and Hans van der Meer. Color and black and white, 8¼ x 11¾ in. (21.0 x 29.7 cm), 64 pages, softcover. Published by KesselsKramer, Amsterdam, 2007.

in almost every picture #5: Collected and edited by Erik Kessels and Marion Blomeyer. Color and black and white, 6⅛ x 7⅞ in. (15.5 x 20.0 cm),

146 pages, softcover. Published by KesselsKramer, Amsterdam, 2006. *Loving Your Pictures*: Collected and edited by Erik Kessels. Texts by Erik Kessels and Pauline Terreehorst. Designed by Angela Lidderdale. Color, 4¾ x 6¾ in. (12.0 x 17.0 cm), 14 pages, 30 postcards. Published by KesselsKramer, Amsterdam, 2006.
Models: A Collection of 132 German Police Uniforms and How They Should Be Worn: Designed by Jennifer Skupin. Color and black and white, 6¼ x 13½ in. (15.5 x 32.0 cm), 144 pages, softcover, boxed edition. Published by KesselsKramer, Amsterdam, 2006.
Useful Photography #006: Collected and edited by Hans Aarsman, Claudie de Cleen, Julian Germain, Erik Kessels, and Hans van der Meer. Color and black and white, 8¼ x 11¾ in. (21.0 x 29.7 cm), 88 pages, softcover. Published by KesselsKramer, Amsterdam, 2006.
Wonder: Rejected photographs rescued by Sabine Verschueren, Erik Kessels, Hans Wolf, and André Thijssen. Color and black and white, 6⅝ x 9⅜ (16.7 x 24.0 cm), 144 pages, softcover. Published by KesselsKramer, Amsterdam, 2006.
in almost every picture #4: Black and white, 6⅛ x 7⅞ in. (15.5 x 20.0 cm), 144 pages, softcover. Published by KesselsKramer, Amsterdam, 2005.
Useful Photography #005: Collected and edited by Hans Aarsman, Claudie de Cleen, Julian Germain, Erik Kessels, and Hans van der Meer. Color, 8¼ x 11¾ in. (21.0 x 29.7 cm), 88 pages, softcover. Published by KesselsKramer, Amsterdam, 2005.
in almost every picture #3: Color, 6⅛ x 7⅞ in. (15.5 x 20.0 cm), 178 pages, softcover. Published by KesselsKramer and Artimo, Amsterdam, 2004.

Useful Photography #004: Photographs by Ad van Denderen. Edited by Hans Aarsman, Claudie de Cleen, Julian Germain, Erik Kessels, and Hans van der Meer. Color, 8¼ x 11¾ in. (21.0 x 29.7 cm), 76 pages, softcover. Published by Artimo, Amsterdam, 2004.
in almost every picture #2: Collected and edited by Erik Kessels and Andrea Stultiens. Color, 6⅛ x 7⅞ in. (15.5 x 20.0 cm), 214 pages, softcover. Published by KesselsKramer and Artimo, Amsterdam, 2003.
Remind: Collected and edited by Hans Eijkelboom, Erik Fens, Paul Kooiker, Paul Bogaers, and Erik Kessels. Black and white, 8⅛ x 11⅜ in. (20.7 x 29.0 cm), 138 pages, softcover. Edition of 200. Published by De Beyerd, Breda, the Netherlands, 2003.
Useful Photography #003: Collected and edited by Hans Aarsman, Claudie de Cleen, Julian Germain, Erik Kessels, and Hans van der Meer. Color and black and white, 8¼ x 11¾ in. (21.0 x 29.7 cm), 192 pages, softcover. Published by Artimo, Amsterdam, 2003.
Useful Photography War Special: Collected and edited by Hans Aarsman, Claudie de Cleen, Julian Germain, Erik Kessels, and Hans van der Meer. Color, 8¼ x 11¾ in. (21.0 x 29.7 cm), 44 pages, softcover. Published by Artimo, Amsterdam, 2003.
Hot or Not: Color, 8¼ x 11¾ in. (21.0 x 29.7 cm), 56 pages, softcover. Published by KesselsKramer and Gerrit Rietveld Academie, Amsterdam, 2002.
in almost every picture #1: Color, 6⅛ x 7⅞ in. (15.5 x 20.0 cm), 274 pages, softcover. Published by KesselsKramer and Artimo, Amsterdam, 2002.

Useful Photography #002: Collected and edited by Hans Aarsman, Claudie de Cleen, Julian Germain, Erik Kessels, and Hans van der Meer. Color, 8¼ x 11¾ in. (21.0 x 29.7 cm), 256 pages, softcover. Published by Artimo, Amsterdam, 2002.

Useful Photography #001: Collected and edited by Hans Aarsman, Claudie de Cleen, Julian Germain, Erik Kessels, and Hans van der Meer. Color and black and white, 8¼ x 11¾ in. (21.0 x 29.7 cm), 60 pages, softcover. Published by Artimo, Amsterdam, 2001.

The Instant Men: Photographs by Erik Kessels. Color, 8½ x 8¾ in. (21.0 x 22.0 cm), 44 pages, softcover. Published by Do Publishing, Amsterdam, 1999.

Missing Links: Photographs by Erik Kessels. Edited by Julian Germain. Color, 4⅜ x 5⅜ in. (11.0 x 13.5 cm), 24 pages, hardcover. Published by Do Publishing, Amsterdam, 1998.

BIOGRAPHIES

HANS AARSMAN (essay) is a photographer, novelist, performer, playwright, curator, and journalist. In all these areas his work is best described as fieldwork: empirical investigations into the significance of his surroundings. For Dutch broadsheet *De Volkskrant*, he writes a popular weekly column on news photography, conducting a detective-like investigation into a particular news photograph, its hidden agendas, and how it came to be constructed. Twice a year, with Erik Kessels and Julian Germain, he publishes *Useful Photography*, the magazine on photography that comes in handy and is beautiful in

its own way. In March 2017, Aarsman will tour the Netherlands with his third one-man show: *Exactly the Opposite*. And that's it for now, folks.

SIMON BAKER (essay) is senior curator of international art (photography), Tate, UK. He is Tate's first curator of photography and joined in 2009 from the University of Nottingham, where he was associate professor of art history. Since joining Tate he has curated or cocurated the following exhibitions: *Exposed: Voyeurism, Surveillance and the Camera* (2010); *Taryn Simon: A Living Man Declared Dead and Other Chapters* (2011); *William Klein + Daido Moriyama* (2012); *Another London* (2012); *Conflict, Time, Photography* (2014); *Nick Waplington/ Alexander McQueen: Working Process* (2015); and *Performing for the Camera* (2016). He recently authored the first major monograph on American painter George Condo (2015).

SANDRA S. PHILLIPS (essay) is the curator of photography emerita at the San Francisco Museum of Modern Art, where she has been head of the department for almost thirty years, producing over forty exhibitions and writing many catalogues. Most recently, she worked on a large presentation of the museum's collection of Japanese photography, which opened in October 2016, and she is preparing for a show, called *American Geography*, about how Americans live and have developed the land.

FRANCESCO ZANOT is Curator of Camera—Centro Italiano per la Fotografia (Turin, Italy) and a critic. He has worked on exhibitions and publications with many international photographers and has curated books

dedicated to artists such as Mark Cohen, Guido Guidi, Luigi Ghirri, Takashi Homma, Linda Fregni Nagler, Francesco Jodice, Gerard Fieret, and Boris Mikhailov. Together with Alec Soth, he is the author of the photoessay *Ping Pong Conversations*. Director of the Master in Photography program organized by the NABA, Milan, he has given classes, conferences, and lectures in numerous academic institutions, among them Columbia University, New York; American Academy, Rome; and IUAV, Venice. He has been associate editor at Fantom since its founding in 2009.

ACKNOWLEDGMENTS

Many lives are not lived alone and so I want to give a special thanks to:

Roland Buschmann and Jeroen Bijl for all the exhibition designs.

Francesco Zanot, Simon Baker, Hans Aarsman, Sandra S. Phillips, and Angela Lidderdale for their contributions to this book.

Useful Photography editors throughout the years:
Hans Aarsman, Hans van der Meer, Claudie de Cleen, Frank Schallmaier, Adriaan van der Ploeg, and Julian Germain.

Many thanks to:
Lorenza Bravetta, Francesco Zanot, Walter Guadagnini, and Alain Bieber.

On a general note:
KesselsKramer, Lesley Martin, Marion Blomeyer, Andrea Stultiens, Michel Campeau, Joep Eijkens, Hironori Akutagawa, Gijs van den Berg, Christien Bakx, Toon Michiels, Thomas Mailaender, RVB Books, Thomas Sauvin, Pauline Terreehorst, Erik Steinbrecher, Erik van der Weijde, Sabine Verschueren, Hans Wolf, André Thijssen, Marla Ulrich, Sanne van Ettinger, Kara Fraser, Christian Bunyan, Paul Kooiker, Christine Otten, Editorial RM, Ria van Dijk, Fred & Valerie, Larbi Laaraichi, Cyril van Sterkenburg, Piet and Tiny Kessels, Lies Willers, Merien Kunst, Maria Kessels, Thieu Kessels, Sjeng Kessels, and Margje de Koning.

And last, many thanks to all the producers of the festivals and museums I have exhibited at since 1999.

THE MANY LIVES OF ERIK KESSELS
All works by Erik Kessels
Introductory text by Francesco Zanot
Additional texts by Hans Aarsman, Simon Baker,
and Sandra S. Phillips

Designer: Angela Lidderdale
Project Editor: Lesley A. Martin
Production Director: Nicole Moulaison
Production Manager: Thomas Bollier
Assistant Editor: Samantha Marlow
Senior Text Editor: Susan Ciccotti
Copy Editor: Sally Knapp
Work Scholars: Simon Hunegs, Melissa Welikson

Additional staff of the Aperture book program includes:
Chris Boot, Executive Director; Sarah McNear, Deputy Director;
Amelia Lang, Managing Editor; Kellie McLaughlin, Director
of Sales and Marketing; Richard Gregg, Sales Director, Books;
Taia Kwinter, Assistant to the Managing Editor

APPENDIX — COLOPHON

CAMERA
Centro Italiano
per la Fotografia

(... Found)

Published in collaboration with CAMERA—Centro Italiano
per la Fotografia on the occasion of the artist's mid-career
survey exhibition *The Many Lives of Erik Kessels*, curated
by Francesco Zanot, opening in Turin in February 2017
and subsequently traveling.

Additional staff of the CAMERA Department of Exhibitions includes:
Francesca Spiller, General Coordinator; Carlo Spinelli,
Technical Area Manager; Arianna Visani, Assistant Curator

Exhibition schedule:
CAMERA—Centro Italiano per la Fotografia,
Turin, Italy, May 31–July 30, 2017

Kulturzentrum NRW-Forum Düsseldorf,
August 5–November 5, 2017

Image on page 252 courtesy Associated Press/Frank Augstein.

First edition, 2017
Printed by Artron in China
10 9 8 7 6 5 4 3 2 1

Library of Congress Control Number: 2016957043
ISBN 978-1-59711-416-5

To order Aperture books, contact:
+1 212.946.7154
orders@aperture.org

*For information about Aperture trade
distribution worldwide, visit:*
www.aperture.org/distribution

aperture

Aperture Foundation
547 West 27th Street, 4th Floor
New York, N.Y. 10001
www.aperture.org

Aperture, a not-for-profit foundation, connects the
photo community and its audiences with the most
inspiring work, the sharpest ideas, and with each
other—in print, in person, and online.